the CUT-OUTS of HENRI MATISSE

the CUT-OUTS of HENRI MATISSE

JOHN ELDERFIELD

George Braziller New York

Published in the United States in 1978 by George Braziller, Inc.
Copyright © George Braziller, Inc., 1978
All rights reserved
Text may not be used in any other publication without written permission
from George Braziller, Inc.
For information address the publisher:
George Braziller, Inc.
One Park Avenue, New York 10016

Library of Congress Cataloging in
Publication Data

Matisse, Henri, 1869–1954.
 the Cut-Outs of Henri Matisse.
 Bibliography: p.
 1. Matisse, Henri, 1869–1954.
I. Elderfield, John. II. Title.
N6853.M33A4 1978 709'.2'4 78–56303
ISBN 0–8076–0885–8
ISBN 0–8076–0886–6 pbk.

Printed in the United States of America
First Printing
Designed by Allan Mogel

Credits: Helene Adant, Paris, 100, 101, 102, 103, 104 (above, 106, 107,
110 (above), 112 (bottom), 113, 115 (below), 116, 117, 118, 119, 120, 121,
122, 123, 124 (above), 125 (below), 126; Biennale di Venezia, Venice,
108 (left); Cameraphoto, Venice, 97, 98, 127 (below); Robert Capa,
Magnumfoto, Paris, 104 (below); Henri Cartier-Bresson, Magnum-
foto, Paris, 99, 125 (above); Dimitri Kessel, Lifephoto, Paris, 127,
(above), 105, 112 (above); The Museum of Modern Art, New York, 103,
109, 115, (above); Paris Match/Carone, Paris, 108 (right), 111; John
Rewald, New York, 110 (below), 114.

CONTENTS

Acknowledgments

I would like first to express my thanks, and those of the publisher, to Mr. Pierre Matisse and Mme. Marguerite Duthuit, without whose support and generous cooperation this volume could not have been realized. I am also especially indebted to Jack Cowart, Jack D. Flam, Dominique Fourcade and John Hallmark Neff, whose important catalogue of Matisse's cut-outs made a retrospective account like mine possible. Additional thanks are due to Jack Cowart for his kind assistance in facilitating the photography of a number of the cut-outs. I owe a particular debt to John Rewald, for opening to me the records of his visits with Matisse, and to Hélène Adant, for showing me a large number of photographs of Matisse and his studios, some of which are reproduced here. To the other photographers, and especially to the owners or custodians of all the works illustrated here, go very many thanks for their kind cooperation.

At The Museum of Modern Art, my secretary Diane Gurien, and Judith Cousins, Researcher of the Collection, aided my work on Matisse in numerous ways. Antoinette King, Senior Paper Conservator, gave me the benefit of her detailed knowledge of the cut-outs, and Richard Tooke and his colleagues in the Department of Rights and Reproductions were helpful in arranging photography at short notice. It was an education to work with George Braziller and his staff; I am particularly indebted to Julianne Griffin for her highly professional assistance. Finally, my wife Joyce, my most patient and objective reader, discussed with me the manuscript in its various stages of development; the book is much better for it, and to her it is gratefully dedicated.

Introduction

It is a commonplace that great artists, in the later stages of their careers, often develop a new style which is barely predicated in their earlier work. It is astonishing nevertheless that Henri Matisse, the greatest painter of the twentieth century, gave up painting in the last years of his life to create the works of his final maturity in a medium—paper cut-outs—that he had first taken up at around sixty years of age, and then not as a true medium of art at all, but as a mechanical aid in fixing the imagery of his paintings and as a form of maquette for his decorative commissions. From these merely utilitarian origins in the early 1930s, paper cut-outs gradually assumed more and more importance for him: by the mid-1940s, he was conceiving them as independent pictorial works; by the time of his death in 1954, he had created works of truly outstanding quality and importance that drew together—in an amazingly economical way—the threads of his entire life's work. "I have attained," he said, "a form filtered to the essentials."[1]

In creating each of his mature cut-outs, Matisse used two distinct processes which generally corresponded to the two separate 1930s sources from which the medium derived: image making and decorative organization. In 1952, he described his methods to the writer André Verdet,[2] and began by talking of the preparations he would make before starting to cut out images using as an example a simplified image of a snail he had recently made (Fig. 1).[3]

"That paper cut-out, the kind of volute acanthus that you see on the wall up there, is a stylized snail. First of all, I drew the snail from nature, holding it between two fingers; drew and drew. I became aware of an unfolding. I formed in my mind a purified sign for a shell. Then I took the scissors." Thus Matisse distilled the essence of the object in the act of drawing (at times, merely drawing in the air was enough to do this) and fixed it in his mind as a "purified sign" which his hand was practiced enough to spontaneously release in the act of cutting. Matisse had conditioned and coordinated both hand and mind and was ready to begin work. Taking a sheet of heavy paper—pre-painted with gouache by one of his studio assistants—from a stockpile in his studio, Matisse carved out the image he held in his mind in a few swift, fluid actions. It was the work

of a moment, this liberation of the image from the paper: the scissors wide open, carving—never clipping—through the sheet of pure color, and the "sign" was there.

It was a process with all the spontaneity of drawing. Indeed, Matisse had found that "scissors can acquire more feeling for line than pencil or charcoal."[4] Conceptually, however, it was more like a sculptor releasing an imagined form from inside a block of marble or stone. Matisse may well have had this in mind when he said that "cutting straight into color reminds me of the direct carving of the sculptor."[5] He may also have been thinking of the resis-

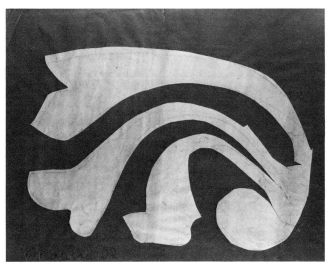

1. *The Snail.* 1952. Paper cut-out, 27³/₁₆″ x 35″. Private Collection, Paris. (Photo: Jacqueline Hyde, Paris)

tance of the heavy painted paper against his shears and the physicality of the medium as compared to painting. Although the cut-outs are in some respects among Matisse's most disembodied and ethereal works, they are also very tangible things. In their creation, Matisse brought something of the physical control of sculpture into the framework of his pictorial art. He cut into color much as if he were making a relief, and technically the cut-outs are in fact very shallow reliefs. The edges of the cut paper directly reveal the actions of his hand. In most of the cut-outs the paint covering the paper shows variations in density that stress their material nature. Matisse was clearly sensitive to the particularly physical nature of these works: while they were in progress he would leave them lightly pinned to the

7

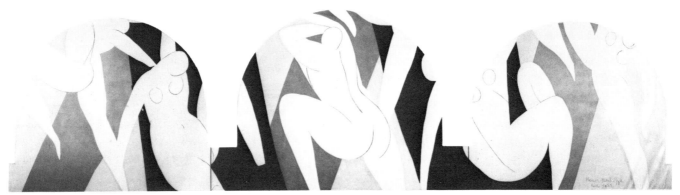

2. *The Dance, I.* 1931–33. Oil on canvas, 11' 8½" x 42' 1". Musée de la Ville de Paris, Paris. (Photo: Photographic Bulloz, Paris)

wall, where they would tremble in the slightest breeze.

This pinning of images to the wall began the second of the two processes which produced the cut-outs: the decorative organization of the preformed signs. This was by far a longer and more deliberative process than the first one; it sometimes lasted several months and even from one year to the next for larger works. Matisse would change the position of the images, adding new ones, at times modifying existing ones, until the desired configuration was reached. Sometimes, images once cut proved to be unusable for the moment, as with the snail form he discussed with Verdet: "I had placed the snail in the big composition of the *Jardin*. (He is probably referring to *The Parakeet and the Mermaid*. [Pl. 34].) But the musical movement of the whole combination was broken. So I removed the snail; I have put it to one side to wait for a different purpose."

Matisse's compositional methods were very straightforward. In the case of many of the smaller cut-outs, little more was involved than deftly positioning one or a few cut-out shapes against a single-colored rectangular ground. For larger works, Matisse often used groups of the smaller cut-outs as building blocks, thus not only adjusting image to image but forming the ground at the same time. At times, particularly with maquettes for commissions with prescribed dimensions, a ground of variously colored rectangles was laid down first to receive the imagery. In the late, mural-sized works, however, the white wall itself was the ground. In the laborious process of adjustment, Matisse fixed the brightly colored images so they coexisted on this white surface, to speak together with one voice, actually modifying the whiteness itself and giving it a unique atmosphere. In explaining this to Verdet, Matisse referred to the same work in progress: "Observe this big composition: foliage, fruit, scissors; a garden. The white intermediary is determined by the arabesque of the cut-out colored paper which gives this *white-atmosphere* a rare and impalpable quality. This quality is one of contrast. Each particular group of colors has a particular atmosphere. It is what I will call the *expressive atmosphere*." Not until such an atmosphere was created—not until the various colored images fused and vibrated across the ground in a single ethereal mood—did the process of adjustment stop. Then everything was finally pasted down in place.

The paper cut-out was Matisse's major medium of expression in the final decade of his life. It was only during the last half of this decade, however, that it reached its fully developed form. As already noted, the works of the 1930s—from the first recorded use of the technique in planning a mural for the Barnes Foundation in 1931–33 to the cover designs for *Verve* at the end of that decade—were conceived simply as preparatory blueprints for realizations in another medium. One of the versions of the Barnes mural (Fig. 2) carries something of the effect of scissor-sharp drawing and colored paper flatness in its painted surface, suggesting that from the very beginning Matisse was aware of the large-scale decorative potential of the cut-outs. However, it was only during his recuperation after a serious operation in 1941 that, bedridden, Matisse began to concentrate on developing the cut-out technique in its own right. In 1943, he moved out of Nice to the hilltop of Vence. There, at his villa, Le Rêve, he produced his first major cut-out project, the famous *Jazz* suite of 1943–44 (Figs. 9, 11, 19, and Pls. 2–5). Even at this stage, however, these cut-outs were conceived as designs for stencil prints or *pochoirs* to be looked at in a book (published by

Tériade in 1947), rather than as independent pictorial works. This, of course, does not detract from the fact that with *Jazz* cut-outs started to become Matisse's strongest medium of work. After all, some of the great late cut-outs were also produced as maquettes. It merely suggests that Matisse still thought of cut-outs as somehow apart from his principal activities as an artist. What eventually happened was that their growing importance to him changed his very understanding of what his principal activity as an artist should be.

That new understanding reveals itself in his 1946 introduction for *Jazz*.[6] After elliptically summarizing his career, Matisse refers to the new possibilities the cut-out technique offers, then insists that, no matter how established an artist is, he must be open to change, even open to changing his very identity as an artist: "An artist must never be a prisoner of himself, prisoner of a style, prisoner of a reputation, prisoner of success, etc. Did not the Goncourt brothers write that Japanese artists of the great period changed their names several times during their lives? This pleases me: they wanted to protect their freedom." Matisse had found a radically new freedom in his new technique. "What I did before this illness, before this operation," he wrote to a friend, "always had the feeling of too much effort; before this, I always lived with my belt tightened. What I created afterwards represents me myself: free and detached."[7]

With *Jazz* Matisse began using the Linel gouaches that characterized his subsequent cut-outs. He used those colors for *Jazz* because they exactly corresponded to printers' ink colors and therefore guaranteed exact color reproduction.[8] Also in *Jazz* Matisse began extensively to develop a repertoire of formal signs using this highly saturated color. The increasing number of independently conceived cut-outs that followed *Jazz* — the geometric works of 1944–46 (Pl. 10); the more complex studies of 1946–47 (Pls. 11–17); and the first mural-size cut-outs, *Oceania the Sky* (Pl. 6) and *Oceania the Sea* of 1946 (Pl. 7)—can be viewed as Matisse's attempts both to codify his new vocabulary and to create a new syntax especially appropriate to it. In doing this, he was increasingly drawn toward an expansive all-over decorative format. When he began to prepare designs for the Chapelle du Rosaire at Vence in early 1948, he had the

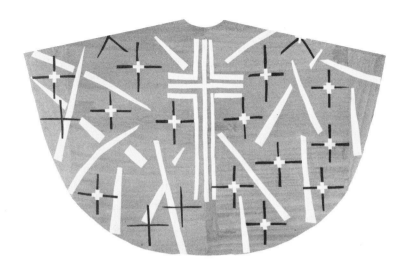

3. *Red Chasuble* (front maquette). c. 1950. Paper cut-out, 52½″ x 6′6⅛″. Collection, The Museum of Modern Art, New York. Gift of Lillie P. Bliss Bequest.

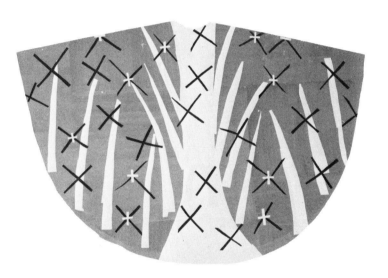

4. *Red Chasuble* (back maquette). c. 1950. Paper cut-out, 50½″ x 6′6½″. Collection, The Museum of Modern Art, New York. Gift of Lillie P. Bliss Request.

opportunity to expand the cut-out technique within a truly decorative context. The experience of designing the Vence chapel windows (Pls. 21–22), chasubles (Figs. 3–4), and tabernacle door—all of which were planned with cut-outs—had the effect of finally consolidating the medium as the locus of Matisse's primary artistic concerns. Indeed, from about 1950 onward, cut-outs assumed such paramount importance for Matisse, and so totally satisfied his artistic ambitions, that they supplanted all other forms except drawing. In 1951, Matisse created his last painting (he had made his last finished sculpture the year before); henceforward—until

his death in 1954 — the paper cut-out was his sole medium for major expression. A number of the works he produced are of such consummate authority that they can stand beside the best of his paintings.

Not all of the late cut-outs are of this quality, or approach it, but as a whole they do form an irrefutably major flowering of his art. However, it was not until 1952 and the last two working years of his life that Matisse discovered the very fullest possibilities of the cut-out medium (and even then found himself at times mining a less productive vein). The great series of Blue Nudes of 1952, including the astonishing environmental work, *The Swimming Pool* (Pl. 27); the brilliant *The Parakeet and the Mermaid* (Pl. 34); and the influential, nearly abstract, *The Snail* (Pl. 38) and *Memory of Oceania* (Pl. 39) of 1952–53, thus stand at the apex of some twenty years of work on cut-outs. Matisse himself acknowledged that the cut-outs were a fitting culmination of his entire career.[9]

During the long process of refinement from the early 1930s to the early 1950s, Matisse was gradually understanding the characteristics of the cut-out medium. He was, in effect, discovering it as a vehicle for major art. As a medium, the paper cut-out is virtually unique to Matisse. Collage, to which the cut-out technically relates, had traditionally meant the use of cut-out papers, among other "foreign" elements, in what remained in essence paintings, or in the case of *papiers collés*, drawings. Moreover, by virtue of its juxtapositional form, collage had stressed — either explicitly or implicitly — the distinction between the world of art (which received these foreign elements) and the world of external reality (from which they derived), even to the point of making this distinction the very focus of meaning of the art itself. Matisse's cut-outs emerge from an entirely different, indeed opposite, sensibility.

Stylistically, the cut-outs bear very little relation to the collages of the Cubists and their followers. True, passages in some Cubist collages convey that sense of the cutting hand which was to be so important for Matisse: for example, the contoured papers forming the guitar in Picasso's 1913 *papier collé* of that name (Fig. 5). Here, however, the edges are clipped, not carved, making the image of the guitar a flat silhouette without that sense of

implied volume Matisse's contours create. Moreover, shaped forms like this never dominate Cubist collages. Cubist forms are far more frequently rectilinear, and therefore more abstract and anonymous, and are trued and faired to the geometry of the picture surface, producing an effect totally distant from that of Matisse's work. When Cubist-based collage reached its most complete definition in the early work of Kurt Schwitters (Fig. 6), shaping as such was almost entirely expunged: instead of contouring or creating form, arranging material that was already formed came to dominate the collage aesthetic. This remained the case in the assemblages of the Dadaists and Surrealists. Although the rectilinearity of Cubism was abandoned by these artists, the use of preformed materials was not. The juxtapositional mode characterizes virtually all collage before Matisse. Such a mode was anathema to the spirit of Matisse's art.

Collage had focused attention on the balance and reciprocation between the real and the painted, between reality and art, and on their conflicting claims — which the particularly modern self-consciousness about the autonomy of art had made newly evident. Matisse's art, in contrast, was an attempt to resolve that competition, to find ways in which to keep in contact with reality all the more. Simply to juxtapose the natural and the artificial, as collage did, was therefore of absolutely no interest to him. From the first he wanted accord, to recover the balance between art and nature which modern awareness of the artificiality of art threatened to break.

The only earlier collages that significantly relate to Matisse's cut-outs are Jean Arp's, with their generalized biomorphic signs (Fig. 7). Although the whole ethos of Matisse's art is certainly as far removed from Surrealism as it is from Cubism, Matisse shares with the abstract Surrealists one common artistic source: the abstracted forms of Art Nouveau and Symbolist art. These lie behind both Matisse's organicism and Arp's biomorphism as well as behind the biomorphism of Joan Miró (Fig. 10) and André Masson's paintings and the analogous formal vocabulary of Paul Klee and Wassily Kandinsky's art (Fig. 8). All of these artists rejected, in their different ways, the geometric vocabulary of Cubism in search of

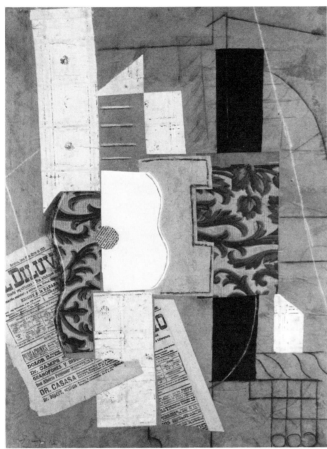

5. Pablo Picasso: *Guitar*. 1913. Papier collé, 26⅛″ x 19½″. The Museum of Modern Art, New York. Promised gift of Nelson A. Rockefeller. (Photo: Charles Uht)

6. Kurt Schwitters: *Merzz 19*. 1920. Collage, 7½″ x 5⅞″. Yale University Art Gallery. Gift of Collection, Société Anonyme.

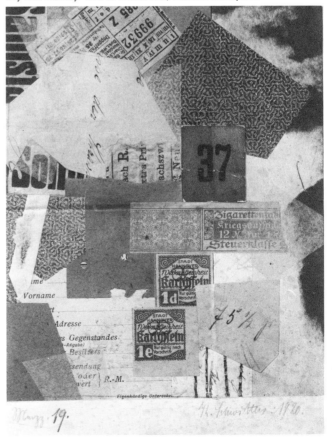

7. Jean Arp: *Collage*. 1941–2. Collage and oil, 18.5 x 24.6 cm. Kunstmuseum, Basel.

something that would express the instinctive rather than the mechanical world, and they found the heritage of Symbolism an especially potent one. The Symbolist impulse was important for twentieth century art in that, unlike Cubism, it did not bring with it an enforced distinction between the autonomous world of art and the world of external reality. Indeed, it affirmed the contiguity of these two worlds. The stylized organic forms of Symbolism and Art Nouveau, although easily vulgarized into the merely decorative, could equally fulfill a far more meaningful role as basic organic elements that

8. Wassily Kandinsky: *Succession*. 1935. Oil on canvas, 31⅞″ x 39⅜″. The Phillips Collection, Washington, D.C.

9. *Jazz*, Plate 17, *The Lagoon*. 1947. Stencil print after paper cut-out maquette of 1944, 16⅝″ x 25¾.″ Collection, The Museum of Modern Art, New York. Gift of the artist.

10. Joan Miró: *Person Throwing a Stone at a Bird*. 1926. Oil on canvas, 29″ x 36¼″. Collection, The Museum of Modern Art, New York. Purchase.

express an underlying natural order behind surface appearances, thus combining pictorial abstractness and natural reference in one mode.

This was important to both the abstract Surrealists and to Matisse, but in crucially different ways. For the Surrealists, biomorphism was a way of giving their interior mental images a universality that alluded to the natural world. Matisse's art, in contrast, was actually rooted in the natural world. He worked away from it as he painted, seeking to give his images their own kind of universality as condensed signs, but nature was his constant point of reference. This separates him from the Surrealists, who eschewed perceptual sources.

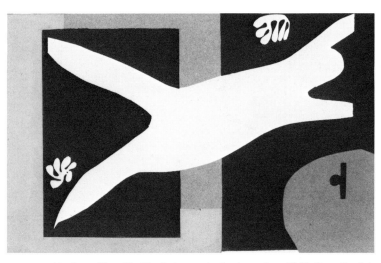

11. *Jazz*, Plate 12, *The Swimmer in the Aquarium.* 1947. Stencil print after paper cut-out maquette of c. 1944, 16⅝" x 25¾". Collection, The Museum of Modern Art, New York. Gift of the artist.

Moreover, while certain individual images in Matisse's cut-outs do bear comparison with those in biomorphic Surrealist works, comparison of the way in which images are combined shows that Surrealism, like Cubism, was an art that based itself in the juxtapositional mode. Indeed, it carried Cubist juxtaposition to a new drama of the irrational, bringing together imagery that was deliberately disjunctive in character. Hence, it, too, spoke of a break in the harmony between reality and its representation and of a self-consciousness of the alienation of art from nature. The reassertion of harmony and the healing of alienation is a basic theme of Matisse's art.

Since the method of Matisse's cut-outs involved the physical fixing of the images of nature in the decorative context of art, we are therefore afforded a close and intimate view, as nowhere else in Matisse's art, of just how art and nature are brought into accord. Although the two-part process of the cut-outs was central to the medium itself, and as such changed the parameters of Matisse's art in some significant ways, the two parts of the equation—image and decoration—had always been of major concern to him. A belief in the inviolability of images, in face of their dissolution by the most advanced of his contemporaries, had been ever the locus of his commitment to painting the natural world. A preoccupation with the decorative had been in large part responsible for the advancement of his own painting. Fixing imagery to the decorative picture surface was the central issue he faced when beginning every painting. He wanted to possess the essential character of nature in images that were so indivisible from the decorative fabric of the work that the natural and artificial became one. He has done this, moreover, in paintings whose very subjects were the resolution of the two states: pastoral subjects and serene, decorative interiors representing a world of harmony and simplicity—in short, a world that approximated the ideal conditions of art itself.

The iconography of the cut-outs, as we shall see, develops Matisse's formulation of this ideal, timeless world. Indeed, the grandest of his cut-outs not only depict such a harmonious environment but were designed as decorations actually to create one. In this respect the cut-outs look back to Matisse's first great period of decorative art, opened in 1906 with the

Bonheur de vivre (Fig. 12). Matisse himself pointed to this connection when he said in 1951: "From *Bonheur de vivre* — I was thirty-five then — to this cut-out — I am eighty-two — I have not changed . . . because all of this time I have looked for the same things, which I have perhaps realized by different means."[10]

It is significant that Matisse fixed the beginning of the process that led to the cut-outs to 1906 rather than, say, to one year before when he created Fauvism, or to 1900 when he first found himself a painter. When Ma-

tisse's art is viewed retrospectively, it reveals two generally contrasting pictorial approaches. The differences between them are more a matter of emphasis than absolute, for one conception informed both: "a meditation on nature, on the expression of a dream which is always inspired by reality."[11] Nevertheless, there is a definite oscillation between two poles. From 1900 to 1906, climaxing in the invention of Fauvism with paintings like the famous *The Open Window, Collioure* (Fig. 13), his art tended to be analytical and empirical, concerned with

12. *Bonheur de vivre*. 1905–6. Oil on canvas, 68½″ x 93¾″. Photograph Copyright by The Barnes Foundation, Merion, Pa.

15

the representation of observed objects in a flattened and abstracted, but implicitly three-dimensional space. The brushwork was loose and spontaneous. The placement of small areas of color, intuited from (though not limited by) direct observation, constructed form. Imagery was created as part of the development of an often ambiguous but still fairly tangible space. This approach of 1900–1906 was later taken up again, although in a significantly revised form, in Matisse's so-called Nice period of 1917–1929. But preceding the Nice period, and then after it — in the lead-up to the cut-outs — a second approach dominated his art.

The period 1906 through 1916 in Matisse's art is characterized by a particularly abstract and synthetic approach to picture making. In the years up to 1910, climaxing in the explicitly decorative works *Dance* (Fig. 14) and *Music*, imagined subjects came into their own. Although the individual components of these pictures are all ultimately derived from observation of specific models, they produce the effect of an invented world. The arrangement of large, open forms — precursors of the "signs" of the cut-outs — across a rigorously flat yet intangible and symbolic space dominated Matisse's art. Whatever sense of volume exists was created by drawing — as happened later with the scissor drawing of the cut-outs. The figural cut-outs, like the Blue Nude series (Pls. 32, 33, 35), bear explicit comparison with the figure paintings of this early period, down to their common organic and curvilinear contours, a hallmark of Matisse's first and last decorative styles. The years 1906–1910 also saw a gradual heightening of the intensity of color and, with it, a new, more reticent, sense of facture. The paint itself is generally thinner and flatter, and the brushwork as such far more restrained. The colored surface therefore never obliterates the sense of the ground beneath — which "breathes" through the color, charging the surface with a great sense of spaciousness and airiness. Along with this openness and expansiveness of the picture surface, Matisse's paintings become physically larger in scale, moving from the parameters of easel painting to almost mural-size decoration, an effect reinforced by the all-over balance of forms across their flat surfaces and by their restful subjects. As part of this decorative trend, all-over patterning came to dominate some works, most

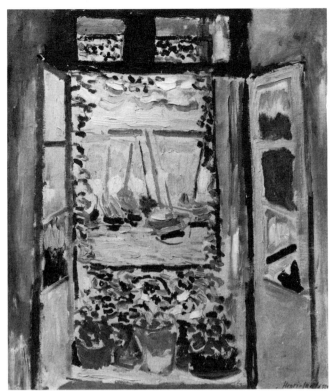

13. *The Open Window, Collioure.* 1905. Oil on canvas, 21¾" x 18⅛". Collection, Mr. and Mrs. John Hay Whitney, New York. (Photo: Peter A. Juley & Son, New York City)

noticeably the *Interior with Aubergines* of 1911 (Fig. 15), which directly prefigures cut-outs like *Large Decoration with Masks* of 1953 (Pl. 41). Once the arabesque possessed Matisse's art, there emerged a new contrapuntal relationship of drawing and color so that each may be viewed separately — this was a purification of painting into its constituent parts — yet each reinforces the other as they join in the creation of imagery. The cut-outs were to be an attempt "to link drawing and color in a single movement."[12]

In 1911, Matisse reinstated observed scenes as the major focus of his art, and the feeling of intangible space gave way to a sense of specific place. This, however, was still formulated in highly synthetic, symbolic, and decorative terms. And although the curvilinear gave way, in the great experimental works of the mid-teens, to the geometric, the same abstracting impulse carries through. The architectonic, indeed diagrammatic, space of a painting like *The Moroccans* of 1915–16 (Fig. 16) and the highly condensed symbols which form its imagery are fully a part of the movement begun a decade earlier — and equally suggestive of what was to come.

It is unnecessary to follow Matisse's art through to the 1930s when these abstracting tendencies reasserted themselves and laid down the framework for the cut-outs. Since the Nice period paintings of 1917–1929 (Fig. 17) show Matisse returning to a more analytical approach

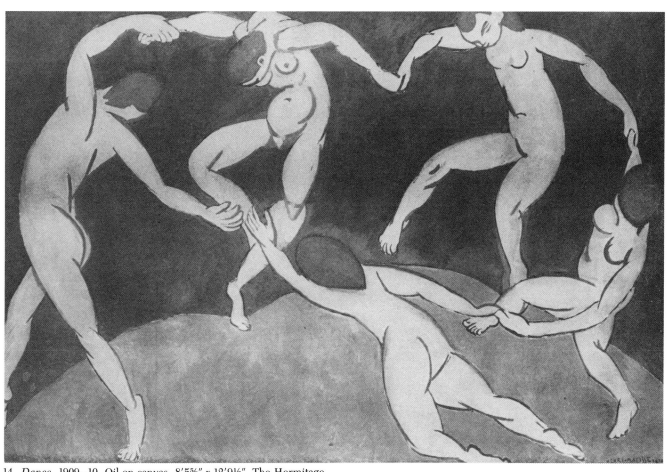

14. *Dance*. 1909–10. Oil on canvas, 8′5⅝″ x 12′9½″. The Hermitage
Museum, Leningrad.

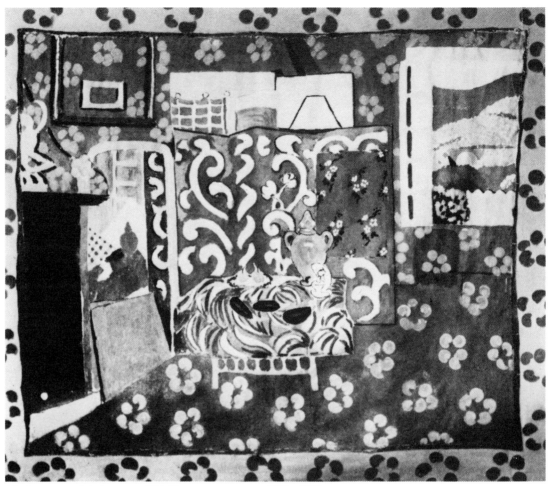

15. *Interior with Aubergines.* 1911. Tempera on canvas, 82¾″ x 96⅛″.
Grenoble, Musée de Peinture et de Sculpture. (Photograph showing
the work with its original painted border.)

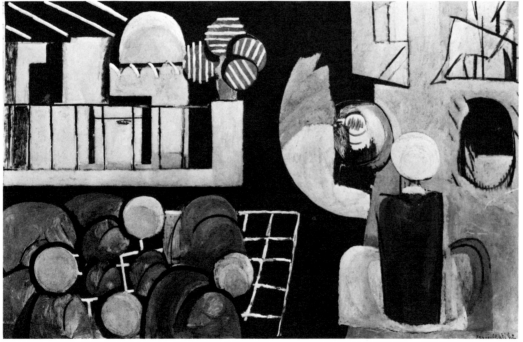

16. *The Moroccans.* 1915–16. Oil on canvas, 70″ x 110½″. Collection,
The Museum of Modern Art, New York. Gift of Mr. and Mrs. Samuel
A. Marx.

to picture making, they are of less concern to us here—except in one very crucial respect. It no longer should be necessary to defend the Nice paintings against the charges of relaxation and mere conservativism once so often leveled against them. It is worth insisting, however, that they bring together Matisse's concerns with an evocative, symbolic, and decorative space and his earlier preoccupation with a very specific observation of the motif. Matisse thus creates a new form of that "dream inspired by reality" where langorous figures charged with a generalized sensuality carry the feeling of an idealized and lyrical world previously only fully achieved in invented subjects into the world of immediate reality. This represents a new synthesis in Matisse's art, and one that is important in its implications for the cut-outs in that Matisse's preoccupation with having paintings "breathe" through the use of white has led him to submit both form and color to the unity of light itself.[13] The Nice paintings are therefore a summation of many of the most pressing concerns Matisse had confronted since his emergence as a painter of stature. If we fail to grasp this, we shall underestimate the gravity of the crisis in his art around 1930 which led eventually to the development of the cut-out medium. The crisis in his art—and it was a very real one—was not merely his dissatisfaction with a conservative mode. He began to experiment again because a whole course of action, grounded in the medium of oil painting, seemed no longer to fulfill his ideals.

Matisse was seeking a new kind of simplification and purification for this art. This meant turning away from the procedures that had created the Nice paintings. He was also seeking, however, to fix his impressions with a sureness and specificity of such an exacting nature that the very suggestiveness of painting of any kind came eventually to stand in the way of what he wanted. The description of objects in space increasingly gave way to the denotation of objects as ideational signs. Although the decoratively formed images of the pre-Nice work distinctly anticipated this new direction, they did not have the fixity and stillness that Matisse now seemed to desire. That only became possible after the Nice period, after Matisse had learned to submit forms to the enveloping light and space that flowed around them, hold-

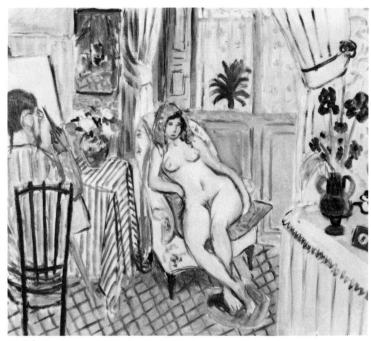

17. *The Artist and His Model.* c. 1919. Oil on canvas, 23⅝″ x 28¾″. Dr. Ruth Bakwin, New York City.

ing them in suspended animation. Such a conception of light and space anticipated the "white atmosphere" of the mature cut-outs just as much as the imagery of the earlier work prepared for the signs that came to inhabit this atmosphere. Hence, the new course of action that began to emerge in Matisse's art in the 1930s both repudiates what came immediately before and also builds upon it, and on the totality of his earlier career.

Matisse's extreme restlessness from around 1930 reflects the tension of this period. Having hardly stirred from one spot for twelve years, he made three trips to America between 1930 and 1933, visited the South Seas, and did very little easel painting, concentrating instead on his commission for the Barnes mural. When he had completed this and returned fully to painting in 1934, he still eagerly accepted other commissions—for book illustrations, a tapestry design, glass engraving, and later, the costumes and decorations for a ballet that produced one of the first important cut-outs (Pl. 1). Matisse also expended a great deal of energy in drawing. After he had returned from his travels, he told his friend, the pub-

lisher Tériade, what had caused him to change his patterns of work: "When you have worked for a long time in the same milieu, it is useful at a given moment to stop the usual mental routine and take a voyage which will let parts of the mind rest while other parts have free rein—especially those parts repressed by the will. This stopping permits a withdrawal and consequently an examination of the past. You begin again with more certainty . . ."[14] It was an attempt to rediscover the mental harmony Matisse believed so essential in approaching his art, and was a way of reviewing his career as a whole, of seeing what elements had lately been refused expression.

Matisse was also in pursuit of an even more abstract and immaterial sense of light and space in which to locate his reality-inspired dream. "Having worked forty years in European light and space," he told Tériade, "I always dreamed of other proportions which might be found in the other hemisphere. I was always conscious of another space in which the objects of my reverie evolved. I was seeking something other than real space."[15] He experienced such a space not where he had expected to find it, in the South Seas, but in New York in brilliant clear sunshine. His struggle to express "something other than real space"—"a very pure, non-material light, a crystalline light"—was one of the two principal obsessions of the rest of his career.[16]

The other was a byproduct of the 1930s simplification of his art. Matisse spoke of a "return to the purity of the means" in his paintings of this decade.[17] In forming their imagery, he abandoned the simultaneous blending of drawing and color in light that had characterized the Nice paintings; he turned instead to a counterpoint of drawing and color similar to that of the early decorative period. Yet, the two elements did not come together as they had then. This time, Matisse's search for a generalized, highly abstract space was beginning to expel volume-suggestive drawing lest it pin down and particularize the space of the painting and evaporate its immaterial quality. We see the consequences of this in the large, simplified works of the later 1930s, such as *Music* of 1939 (Fig. 18). In works like this, Matisse adjusted open, flat areas of color one against the next so that space became almost exclusively a property of color

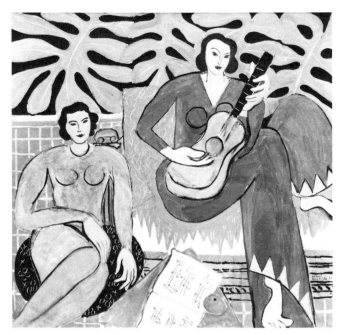

18. *Music*. 1939. Oil on canvas, 45¼″ x 45¼″. Albright-Knox Art Gallery, Buffalo. (Photo: Greenberg-May Production, Inc., New York)

alone—even more so than in the early decorative works in which drawing and color fused to create space. The late 1930s paintings are far more resolutely flat and frontal even than *Dance* or *Music* of 1910 in which the contours of the figures suggest volume. In the late 1930s, drawing contours form only as part of a surface arabesque, and it is often an entirely independent overlay across the surface of the color. What is more, the patient, deliberated method of this kind of painting (we can see it in the in-process photographs Matisse had made at this time[18]) was in very marked contrast to the remarkable spontanetity of his contemporary drawings — a spontaneity he was finding necessary to the act of drawing in order to release his mental images with the maximum of economy. The two-step process of the cut-outs — the spontaneous and the deliberated — has its source in Matisse's art of the 1930s.

In the cut-outs, the spontaneous and the deliberated serve a single goal; in the late 1930s, however, they served separate goals. The components of his art were drifting apart. In January 1940, he wrote to Bonnard: "My drawing and my painting are separated."[19] He then summarized the problem: "My drawing suits me, for it renders my particular feelings. But I have a painting, bridled by new conventions of flatness through which I should express myself entirely, exclusively in local tones, without shading, without modelling, which should react with one another to suggest light, spiritual space. This hardly goes with my spontaneity which makes me balance a large work in a minute because I reconceive my picture several times in the course of its execution. . . . I have found a drawing which, after the preliminary work, has the spontaneity that empties me entirely of what I

feel. . . . But a drawing by a colorist is not a painting. He must produce an equivalent in color. It is this which I do not achieve."

Matisse had achieved new simplicity only to find himself in yet another crisis. External factors—the onset of the war, his failing health — exacerbated it. In September 1940 he wrote to his son Pierre of "trying hard to settle down to my work . . . but this kind of uncertainty in which we are living makes it impossible; consequently I am afraid to start working face-to-face with objects which I have to animate with my own feelings. . . . I hope I shall start painting again soon, but that overwhelms me so — I have to invent and that takes great effort for which I must have something in reserve. Perhaps I would be better off somewhere else, freer, less weighted down."[20] In January 1941, he underwent major surgery that nearly ended his life and severely traumatized him. In the long period of recuperation from 1941 to 1943, he turned to physically less demanding media than painting: drawing and cut-outs. What happened in those years changed the character of his art yet again, and in some respects more radically than ever before. By 1942, he was writing to Marquet: "It seems to me that I am in a second life."[21]

In 1943, talking to the poet Louis Aragon about pictorial "signs," Matisse started to make reference to painting on a grand scale, then paused, thinking perhaps how curious this sounded coming from a still weak man. But pressed by Aragon, he continued. He was speaking, he said, "as if I were going to tackle large-scale compositions: it's odd, isn't it? As if I had all my life ahead of me, or rather a whole other life. . . . I don't know, but the quest for signs—I felt absolutely obliged to go on searching for signs in preparation for a new development in my life as a painter. . . . Perhaps after all I have an unconscious belief in the future life . . . some paradise where I shall paint frescoes . . ."[22]

Matisse, of course, did not have a new life as a painter; he abandoned painting to make his large-scale cut-out compositions, but his preoccupation with "signs" was indeed the preparation for this new development in his art. It was through the quest for signs that drawing and color, whose separation had caused him so much

concern, were finally reunited. The quest for signs, though not expressed in this particular way, had been essential to his art since *Bonheur de vivre.* It had led to his dissatisfaction with the violent flux of Fauvism. Although his preoccupation with imagery was a preoccupation with the world of appearances, it was also far more than this. He did not, he continually insisted, "literally paint" nature, "but the emotion it produces upon me."[23] The process of representation itself was a process of empathizing with nature, discovering pictorial equivalents for observed objects, images that best expressed their essential character. Although Matisse was a painter of objects, he was never a painter of effects. The sheer surface of the world seemed to him too fugitive and unstable, too arbitrary a thing to truly represent the reality of what he observed. The essential had to be quarried out in the act of working. As he wrote in the famous "Notes of a Painter" in 1908: "Under this succession of moments which constitutes the superficial existence of things animate and inanimate and which is continually obscuring and transforming them, it is yet possible to search for a truer, more essential character which the artist will seize so that he may give to reality a more lasting interpretation."[24] This "essential character" of a thing is what he later called its "sign."

The concept is very much a Symbolist one — wanting to find a reality behind mere appearances — yet Matisse did not want to create some purely conceptual symbol. It had to be distilled from direct observation in a way analogous to his admired Cézanne's synthesis and condensation of an object to express its enduring qualities, but with a degree of freedom from the model far greater than Cézanne allowed himself. Truth to nature did not mean being subject to nature. It meant (as it did for Cézanne) creating an independent pictorial harmony parallel to nature that expressed the vividness of his sensations and emotions before the motif. His response to nature was the true subject of his art. This made it necessary to alter what he saw, to modify its merely local and temporal dimensions. Hence the removal from immediate reality —and from topical, disturbing subjects —that came to characterize Matisse's art, and the search for something unconfined by time and space in the free world of memory that matched and consolidated the

calm and eternal mood of the subjects themselves. A harmony of drawing and color was essential to this endeavor, so that each image or view of nature was complete and self-contained, exactly expressing that "clear image of the whole" he felt to be so important.[25] Color must not simply 'clothe' the form; it must constitute it." "When I use paint, I have a feeling of quantity—a surface of color which is necessary to me, and I modify the contour in order to determine my feeling clearly in a definitive way."[26] This quality of exact definition through the union of drawing and color is precisely what Matisse had found missing in his works of the late 1930s. He had found exactness in his drawings — by drawing and redrawing the same object until he spontaneously extracted its essence — and he had refined this method during his period of recuperation in the superb *Themes and Variations* drawings of 1941–42. But "an equivalent in color" had not been achieved. In 1943, however, the breakthrough finally came.

"This afternoon," he wrote in a letter on March 31, 1943, "I was out of bed from three to half past seven. I have been working with color, and I have the conviction of having witnessed the great breakthrough in color which I had been waiting for, analogous to that which I had made in drawing last year. I am deeply contented, happy! I have some good days in prospect, God willing."[27] He had found a way to bring drawing and color together in a far more complete synthesis than ever before, "drawing with scissors on sheets of paper colored in advance, one movement linking line with color, contour with surface."[28] "The cut-out paper allows me to draw in color. It is a simplification. Instead of drawing an outline and filling in the color — in which case one modified the other — I am drawing directly in color, which will be the more measured as it will not be transposed. This simplification ensures an accuracy in the union of the two means."[29] Pure, pre-existing color replaced painting, and the division of pure color the act of drawing. It was a radical abstractness of Matisse's means, to make art from its most basic components. Art itself is "filtered to its essentials" along with nature. Everything exists in an elemental state, in "something other than real space," and with all the rarity of that "very pure, non-material light" Matisse had been seeking to express:

"not the physical phenomenon, but the only light that really exists, that in the artist's brain."[30]

Throughout the 1940s, Matisse developed a repertoire of formal signs in the new cut-out medium; then, as his works became increasingly ambitious, he sought to create a new syntax appropriate to it. The first major cut-out project, *Jazz* (1943–44), began this process despite the fact that both its sign vocabulary and syntactical form are highly idiosyncratic.[31] The iconography of the circus and music hall which dominates a majority of its twenty plates had not been used previously by Matisse and was not to appear again. Nevertheless, many of the individual signs do prepare for what follows, especially the organic leaf shapes and the generalized images of both torsos and of figures in movement. Some plates in which these predominate directly rehearse themes which later received far more amplified expression. For example, *The Swimmer in the Aquarium* (Fig. 11) looked forward to *The Swimming Pool* of 1952 (Pl. 27) while the *Lagoon* plates (Fig. 9) presage the large decorative works of 1952–53 (Pl. 41 and Figs. 25, 26). Although the way in which Matisse formed and arranged his imagery seems to set apart *Jazz* from his later work, it does—to use Matisse's own way of putting it—lay out the components of the puzzle he was beginning to investigate.[32] The dazzling juxtaposition of highly saturated colors links *Jazz* to Matisse's preceding paintings, as does the narrative composition of many of the plates (here, especially appropriate to the story-telling format of a book). The total effect of *Jazz*—of its color, of the feeling produced by Matisse's cutting, of the confrontation of images on each plate and in the work as a whole—is far more staccato than that of his later works. Although these characteristics persist in some subsequent cut-outs, two other features of *Jazz* had more far-reaching consequences upon the development of the rest of Matisse's art.

One is the geometry of the picture surface. This is the result of Matisse's directly expressing the rectilinearity of the sheets of paper from which the cutting takes place. In *The Swimmer in the Aquarium*, for example, the component sheets are clear in the design, as they are in *The Codomas* (Pl. 4), and *Pierrot's Funeral*, where the rectilinearity is additionally emphasized by the use of

19. *Jazz*, Plate 2, *The Circus*. 1947. Stencil print after paper cut-out maquette of 1943, 14¼ x 21⅝". Collection, The Museum of Modern Art, New York. Gift of the artist.

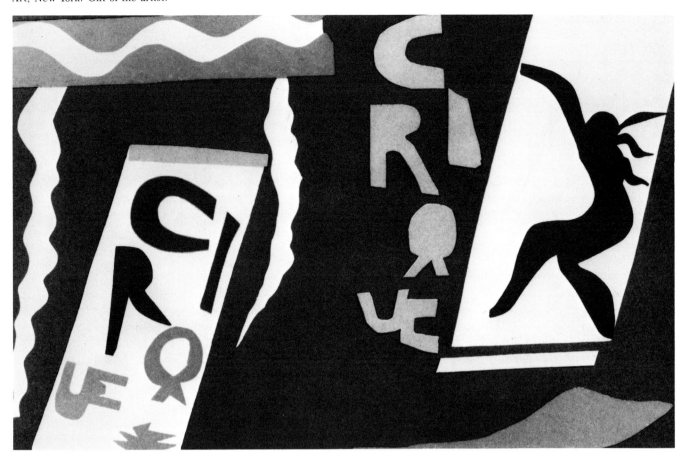

specific "framing" devices — something almost unprecedented in Matisse's earlier art.[33] In *The Toboggan* (Pl. 2), *The Sword Swallower,* and *The Clown,* such framing devices are even more pronounced and are crucial to the coherence of these designs. The second far-reaching characteristic of *Jazz* is the use of white both as a ground on which images are placed, and as a negative space, formed by cutting away images from colored sheets. This negative space reads as a newly "empty" and disembodied form of imagery when the cut-away sheets are placed on a white ground. In *Jazz,* however, the use of white is still in a rudimentary form. Only a few plates — most notably, perhaps, *The Knife Thrower* (Pl. 5) — make use of an open white ground. There are more "negative" or "empty" whites as well as occasional uses of the related device of pulling apart the two sides of a paper separated by one cut (for example, in the top left corner of *The Circus,* Fig. 19, and along the left side of *The Clown*), but it is really only with hindsight that one realizes just how important they are. The use of whites, initiated in *Jazz,* had truly radical implications for Matisse's art that were, however, only fully realized when the trend set in motion with the geometricism of *Jazz* began to be checked. How that geometricism developed should therefore be explored first.

Once sheets of color became the basic components of Matisse's art, it was only natural that they should play a large part in directing its composition. It was also natural that Matisse should want to make something other than "paintings" out of the cut-out medium, but find in it a special character of its own. He therefore by and large abandoned the story-telling aspect of many of the *Jazz* plates, the directly narrative relationship of forms within individual sheets that makes them read as small paintings. Instead, Matisse focused on the potential of plates like *Icarus* (Pl. 3), where one rectangle of paper contains a few images directly related to the center and containing edges of the sheet. With this highly straightforward format, Matisse was able to concentrate on sign making and to build up a rich and varied repertoire of different images: first, in the years 1944–46, highly simplified and geometric forms; then, through the remainder of the 1940s, more active, organic, and aquatic images — tendrils and fruits, birds, beasts, and fish, and figures in increasingly summary outline.

One liability of this method, however, was that the cut-outs tended to remain fairly modest in size. Their formal coherence depended on the fact that the sheets on which the images were placed were of a similar size to that from which the images were cut. Only images of a

23

certain size could be cut spontaneously; if images and sheet were to be related directly, that dictated the maximum dimensions of the paper Matisse used, and hence the scale of the whole work. To escape this limitation, Matisse—in two pairs of highly imposing works of 1946—freed images from their small sheets and spread them out across much larger surfaces. The first pair, *Oceania, the Sky* and *Oceania, the Sea* (Pls. 6–7) seems to have been the more successful. (These cut-outs are now lost and are only known through photographs and through the silk-screens for which they served as maquettes.) The images float on open beige grounds, and regardless of their derivation from the earlier art of Arp, Miró, and Kandinsky (Figs. 7, 8, 10), they exude a freshness and candidness that speaks of sheer spontaneous invention. In the second pair, *Polynesia, the Sky* and *Polynesia, the Sea* (Pls. 8–9), Matisse structures the ground in a checkerboard pattern of tonally contrasting blues across which he positioned the white cut-out forms. Perhaps Matisse mistrusted the absolute openness of the first pair of works and their feeling of evanescent lightness. Only a few cut-outs that followed in the 1940s, such as *The Bird and the Shark* (Pl. 13) and *Composition: Green Background* (both 1947), possess an equivalent sense of unobstructed open space, and they are much smaller. Not until 1952, in *The Parakeet and the Mermaid*, did Matisse fully consolidate the method of his first large-scale works.

It was in the second pair of large-scale works that he found stimulus for the majority of his immediately subsequent cut-outs, particularly in their use of an organizing grid structure. In some of the *Jazz* series, Matisse had put image-containing rectangles side-by-side to make double-page plates. After the *Polynesia* works of 1946, he continued to make single-image cut-outs on a modest scale, but increasingly began to pair, stack, and combine the rectangular sheets to produce grid patterns. Through this procedure, the cut-outs first consistently reached a larger scale and attained a newly ambitious character.

In 1947, Matisse combined his rectangular sheets in a variety of ways. However, each sheet usually contained a single or at least a dominating image, and each, more often than not, seems to have been made independently before being brought together with its family members. Some of these cut-outs directly extend the double-spread book format of *Jazz:* for example, *Composition, Violet and Blue* and *Composition, Black and Red* (Pls. 16–17), which also interestingly show how Matisse used positive and "remainder" images in associated works. In *Amphitrite* and *Composition with Red Cross* (Pls. 11–12), the fields are multipaneled and organized with strong vertical flanking elements, which in the former work comprise stacked-up images and thus prepare for the similar structure in the great *The Beasts of the Sea* of 1950 (Pl. 24). A somewhat ethereal coloration also links *Amphrite* and *The Beasts of the Sea.* In contrast, *Composition with Red Cross* shows Matisse using color at its boldest and most saturated intensity. *Composition (The Velvets)* (Pl. 14) introduced yet another organizational method: stringing panels together to create a long horizontal format, implying a left-to-right "reading" of the work. Once again, this was capitalized upon later, first and most evidently in *The Thousand and One Nights* of 1950 (Pl. 20). In *The Panel with Mask* (Pl. 15), however, Matisse arranges the panels in a vertical grid, one image to each panel in a frank and highly explicit fashion. This vertical grid arrangement dominated Matisse's most ambitious cut-outs from 1948 until 1952.

In perfecting this particular method, Matisse was undoubtedly affected by his experience of designing the windows for the Vence chapel in 1948–49. In that context, grids — in the form of leaded panes of glass — naturally asserted themselves, as did, of course, verticality. In the Vence windows the repetition of similar images supported by an underlying grid provides the essential logic for Matisse's designs. In the first of these designs, the stunning *Jérusalem Céleste* of 1948 (page 100), rectangles of pure and vibrant color, unalloyed by any other kind of imagery, constitute the entire work. This, however, is virtually unique in Matisse's *oeuvre.* Another 1948 design, *The Bees* (Pl. 18), is also composed of purely geometric forms, but they are not aligned to the vertical-horizontal frame of the windows. Generally, Matisse used the colored rectangles as building blocks to pile images upon images in the tight, containing vertical formats, as in *The Tree of Life* cut-outs (Pls. 21–22)—the designs finally used at Vence.

After Vence, the vertical grid format came fully into its own, and the cut-outs finally became more important to Matisse than any of his other work; painting and sculpture were abandoned. In 1950, he made *The Beasts of the Sea* (Pl. 24) and the horizontal *The Thousand and One Nights* (Pl. 20). In 1951 came *The Wine Press* (Pl. 28), *Snow Flowers* (Pl. 25), *Vegetables*, and *Chinese Fish* (Pl. 26) and in 1952, *Nuit de Noël* (Pl. 30). Matisse had hit a truly productive vein, and mined it for all it was worth to create certainly his most important group of cut-outs to date. These are not only very fine works but also instructive ones, for they show that, now that Matisse was making cut-outs of equivalent quality to his paintings, something in his art was changed. The new technique had engendered the change, but it was more than merely a technical one. The mature cut-outs raise questions about the priority of color as the chief expressive agent of Matisse's art and the absolute validity of his often-repeated claim that it was purity and simplicity he was always seeking.

The basic composition of *The Beasts of the Sea* (Pl. 24)—the two piled-up columns—may be simple, but the structure, and the effect, of the work is not. It is Matisse's sheer inventiveness that perhaps strikes one most. The cut-out is a marvel of invention, containing an astonishing variety of organic and aquatic images—algae, corals, fish, snails—yet everything acknowledges the additive upright block structure that organizes the work. The key, perhaps, is the contrapuntal play between the organic and the geometric. From an essentially one-to-one relationship of image and containing rectangle at the base of the work, the imagery begins to reach across the separate strata, floating up to the top of this cross-section lagoon.[34] The active and often unexpected relationships between individual forms and colors—as well as between the two separate piles of forms and colors—further enhance the highly exhilarating variety of this work. Something analogous occurs in *The Thousand and One Nights* (Pl. 20), except here the horizontal format stresses even more the narrative development of imagery essential to both of these works. In *The Wine Press* (Pl. 28), by contrast, this kind of implied movement within the work is tempered. The images lock into the surface geometry like pieces of a jigsaw, forcing a far

more instantaneous perception of the whole. This is true construction with color. Although the other two works are very beautiful in color, their structure is not a purely chromatic one, but as much a matter of formal inventiveness, of a feeling of expressive activity in imagery and composition.

Although this does not imply violent or Expressionistic activity, it is still a significant step away from Matisse's avowed aims of simplicity and calm. Perhaps this was why, in *Snow Flowers* (Pl. 25) and *Vegetables*, and to a large extent in *Nuit de Noël* (Pl. 30), Matisse very obviously simplified his methods, returning to something closer to the effect of *The Panel with Mask* (Pl. 15) where images are more closely identified with their separate parts of the structural grid. This achieved a new degree of clarity and directness, and a new expansiveness of color—if only because the areas of each color are larger—but it necessarily limited the scope of Matisse's invention. Simplification reasserted calm, but the overall gridded balance that brought simplification tended to freeze the flat images in their separate parts of the composition. This would have hindered the free movement of space so essential to Matisse's art had not either the images distinguished themselves from their grounds (in *Snow Flowers* and *Vegetables*), letting space flow around them, or had not (in *Nuit de Noël*) a repertoire of generally similar images, but of different sizes, kept the eye in perpetual animation.

However, simplification of method, as opposed to simplicity of effect, was not, in the final count, Matisse's most fruitful approach. Far more crucial was spatial freedom. When the organizing grid is white, and hangs back to organize freely flowing space, as it does in *Chinese Fish* (Pl. 26), the images themselves may be relatively simple but the effect is of vibrancy combined with calm because of the controlling whiteness of the work. From this point it was only a small, though still remarkable step to dissolve the literal grid, to arrange images according to a generalized grid and to let them reach to each other across an open, disembodied white space. Returning to the expansive horizontal format of *The Thousand and One Nights*, only vastly enlarging it to mural-like scale, Matisse began in 1952 to make one of his very greatest cut-outs, *The Parakeet and the Mermaid* (Pl. 34).

Matisse's whole development was a matter of contrasts. While exploring the decorative potential of the grid method, he also at times used it to make "paintings" out of cut paper. Probably in reaction to his specifically decorative work at Vence, he made *Zulma* (Pl. 19) and *Creole Dancer* (Pl. 23) in 1950. In 1952 before starting on *The Parakeet and the Mermaid*, he made *Sorrow of the King* (Pl. 31). In each of the three works, the compositional logic is obviously derived from painting, and it produces the effect of paintings in paper. The grid is essentially a background; it helps give coherence to the presented images, but is not totally identified with them or fully complementary to them. This is not, of course, to pass judgment on these works — the two 1950 cut-outs are particularly vital and compelling. However, even as Matisse was developing the grid form, and hence bringing his art closer to decoration, he was still looking for ways to invest the cut-outs with certain qualities that had traditionally belonged to his paintings, even to the point of making paintings in paper to do so. The fact that in 1952 he was still looking back over his shoulder shows that even by then the fully developed "all-over" grid format was not totally satisfying all of his ambitions.[35] I have mentioned some of the dilemmas the format created for Matisse, but I think what he himself mainly found missing in these cut-outs was the human figure.

"What interests me most is neither still life nor landscape, but the human figure," Matisse wrote in his "Notes of a Painter." "It is that which best permits me to express my so-to-speak religious awe towards life."[36] That was in 1908, and it remained true for his subsequent career. He recognized that the "human element" should be tempered in "architectural," that is, purely decorative work, but the cut-outs aimed at more than decoration.[37] The figure, it seemed, was required if the authority and the seriousness of painting were to be matched. Matisse returned to the figure in 1952 and produced that year his finest and most important cut-outs. Among these are: the great series of Blue Nudes including *The Swimming Pool* (Pl. 27); *The Parakeet and the Mermaid* (Pl. 34), which contains figural elements within a huge decorative pastoral; and two chromatic masterpieces, *The Snail* and *Memory of Oceania* (Pls. 38–39), in which Matisse was finally able to match his best

paintings without needing to use figures.

But if 1952 was, in the sheer number of important works produced, one of the richest years of Matisse's career, it is a year in which his stylistic development is especially difficult to unravel. Even the most important works mentioned above are really quite different in character, and how they interrelate is far from self-evident. Unless more explicit documentation appears than exists at present, any attempt at a chronology for this year must remain to some extent a matter of conjecture. An attempt must be made, however, not only to satisfy art historical curiosity, but to understand how Matisse finally achieved the great synthesis in his art he had long been seeking.

It has often been assumed that Matisse's art in 1952 followed two separate parallel paths: one initiated by the series of seated Blue Nudes, culminating with *The Swimming Pool*; the other, launched with his work on *The Parakeet and the Mermaid*, which finally led to the decorative murals of 1953. It has recently been recognized, however, that the two paths do interrelate; some of the individual Blue Nudes were tried out and others actually produced for inclusion in that corner of *The Parakeet and the Mermaid* finally filled by the mermaid.[38] This, however, is not the only way in which the works of 1952 interrelate. Matisse that year drew together the important themes of all his previous cut-outs — if not indeed of his previous art as a whole. It was a year that synthesized many of the achievements of an entire career.[39]

The year opened with *Nuit de Noël*, the last of the vertical gridded cut-outs.[40] Matisse had a series of photographs taken to evaluate his progress (page 109). These show that it was made in about five weeks, and completed on February 27. During this time, Matisse developed his original idea of a Christmas Eve sky over a landscape of organic signs into a work containing three zones: sky, earth, and sea. That is to say, he reinterpreted the given Christian iconography to include, at the base of the cut-out, a section which alluded to Oceania. As ever, Matisse found in a commissioned work a way of expressing his own particular iconographic concerns.

Nuit de Noël was followed by *Sorrow of the King* and the return to the figure. This work was completed toward

the end of March, by which time Matisse had made the parakeet of *The Parakeet and the Mermaid* and some of its leaf forms, but probably had not yet conceived the whole panoramic effect. The parakeet was placed on the wall in his bedroom to the left of that on which *Nuit de Noël* had been made, and Matisse only gradually developed the composition onto the adjacent wall. *Sorrow of the King* had been made in the studio next door, and once that was completed, Matisse commenced work on *The Negress* (Pl. 40), attempting to create a figure composition using the same open displacement of discrete images on a white ground he was starting to use for *The Parakeet and the Mermaid*. It was his obsession with the figure that seems to have caused him to suspend work on the mural just started in the bedroom, for it was not further developed until a whole series of figural cut-outs had been made. Matisse was concentrating on bringing to his most advanced cut-out method the figurative imagery used in *retardataire* fashion in the cut-out "paintings" of 1950 and 1952. In fact, the figure of the Negress (inspired by the American *danseuse* Josephine Baker) is based on the figure in the *Creole Dancer* (inspired by another popular dancer, Katherine Dunham). It also relates to the dancing figure at the right of *Sorrow of the King*, particularly in its opened-out pattern of circles and segments of circles. This pattern is only broken by the long tassels hanging from the figure's waist (again derived from similar elements in the preceding work) and by the more curvilinear leaf forms that read as hands, showing a relationship to the foliage in *The Parakeet and the Mermaid*. The other four-leaf patterns were only added early in 1953. The photograph of this work in Matisse's studio (probably in April) shows the earlier state (page 121). Carefully arranged so that it is reflected in the mirror, we see in process the first of the seated Blue Nudes that Matisse worked on *(Blue Nude IV)* (Pl. 35). Did Matisse, one wonders, bring in the Blue Nude and pose it there? For together the seated figure and standing dancer assume the same general relationship as their prototypes in *Sorrow of the King*. At this stage, *Blue Nude IV* certainly shows its derivation from that picture. Having reached something of an impasse with *The Negress*, Matisse apparently turned his attention to the seated figure, for him a far more familiar image.

"One must study an object a long time," he said, "to

know what its sign is."[41] *Blue Nude IV* took a notebook of studies (Fig. 20) and two weeks work of cutting and arranging before it satisfied him.[42] Although the first of the four to be begun, it was completed last. The pose he finally arrived at for all four works — intertwining legs and an arm reaching behind the neck — was long his favorite.[43] One is particularly reminded of the large number of seated nudes from the first half of the 1920s, but variants of the pose go still further back in Matisse's art, for the seated nudes of the 1920s derive ultimately from the somnolent reposed figures of *Bonheur de vivre*. Matisse's entire *oeuvre* reveals a deep sense of continuity in the persistence of certain basic themes. The four seated Blue Nudes of 1952 re-examine one of these themes: the decoratively posed representative of an idealized Golden Age. This retrospective trend is again evidence of Matisse's desire to invest the cut-outs with a charge equivalent to that of his paintings. It reveals something else too: having concentrated his attention on creating decorative organic settings in most of his earlier cut-outs, Matisse was now starting to make figures with which to populate his interior pastoral. The different themes of his art were beginning to converge.

The Blue Nudes refer not only to Matisse's earlier figure paintings but also to his sculptures. They are sculptural in their highly tangible, relief-like quality, in their overlapping, and in the sense of volume created by the scissor-drawn contours; they remain sculptural despite the unity they find in flatness.[44] Even the feeling they evoke is sculptural. They reveal a sense of latent energy and freedom — even at times abandon — that characterizes some of Matisse's most important sculptures. *Blue Nude I* (Pl. 32) in particular may be usefully compared with sculptures like *La Serpentine* of 1909 (Fig. 21). In the cut-out, a narrow arabesque torso twists down the whole design and is stabilized by the strong vertical of the model's left arm. The oppositely placed breasts and exaggerated broad legs are treated in a highly manual fashion, and with a sense of freedom that also characterizes the early sculptures.[45] The sculptural connection points also to the fact that the Blue Nudes were an attempt by Matisse to renew his understanding of the figure before using it in larger compositions. He turned to sculpture, he said, "for the purpose of organiza-

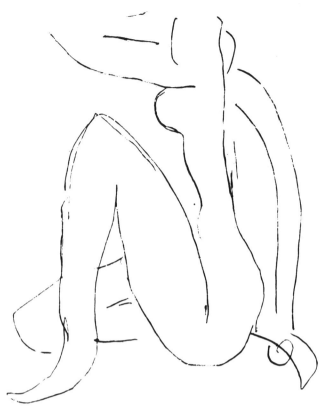

20. *Woman Seated with Arm on Head* (Drawing related to 1952 Blue Nude series cut-outs). 1952. Pencil on paper, 10⅝″ x 8¼″. (Whereabouts unknown.)

tion, to put order into my feelings and to find a style to suit me."[46] The sculptural Blue Nudes were made in exactly this spirit.

They were also made by using only the first — the sign-creating—part of the two-step cut-out process. Since they form single figures, the question of image-to-image arrangement did not arise; nor did the relationship of different colors. In fact, these things were all but precluded in this new method. Whatever juxtaposition of cut-out elements that takes place is dedicated to the creation of single images; multiple colors would have destroyed their unity. Once the image-making process had become so sophisticated, the arrangement of different images and colors posed acute problems. In cut-outs Matisse had created figurative images of astonishing power, only to find them irreconcilable with the settings for which they were designed. To resolve this dilemma was the object of Matisse's art through the rest of this important year.

In April and May of 1952, André Verdet interviewed Matisse and discussed with him *The Parakeet and the Mermaid*, still at an early stage in its development. Matisse referred to the cut-out as "a little garden all around me where I can walk"; his being kept indoors because of his declining health.[47] He was beginning to cut

new images to add to the parakeet and leaves from which he had started. After cutting a simplified snail form (Fig. 1), which he then found unsuited to the composition, he tried out what he called "these bathers that you see at the far end of the garden." It has been assumed that these bathers are the seated Blue Nudes, yet he referred to the Blue Nudes as "those blue women."[48] If he did try the Blue Nudes in *The Parakeet and the Mermaid*, he must have immediately realized how anomalous such self-reflexive images seemed. By "bathers," he more likely

21. *La Serpentine*. 1909. Bronze, 22¼″ high. Collection, The Museum of Modern Art, New York. Gift of Abby Aldrich Rockefeller.

meant some other seated nudes, including the two that formed the early state of *Women and Monkeys* (Pl. 42) and which are indeed visible "at the far end of the garden" in a photograph of Matisse's bedroom taken in the summer of 1952 (page 112). After completing the first group of Blue Nudes in April, Matisse continued to investigate the figure in single-image cut-outs. He was clearly searching for a way to create abstracted signs for the figure of a similar directness and self-sufficiency as the simplified organic motifs he had so refined. The cut-outs he made in May and early June show that he approached this problem in three different ways. Works like *The Frog* (page 114) reorganize the same kind of figure parts that appeared in the seated Blue Nudes in exclusively frontal terms, making more than a passing reference to the open format of *The Negress* in doing so. In contrast, in the original women of *Women and Monkeys* (pages 112 and 114), the *Blue Nude with Green Stockings* (page 112), *La Chevelure* (page 114), and *Woman with Amphora and Pomegranates* (page 114), Matisse avoided the open displacement of figure parts by using continuous silhouettes. Different again are *Woman with Amphora* (page 114) and Venus (Pl. 37), in which the image is formed from the outside, as it were: the figure itself becomes negative space.

The second of these approaches offered the best solution to Matisse when he wanted to combine figural images with self-contained leaf forms, as in *The Parakeet and the Mermaid*. The figure became as flat and abstracted as the leaves themselves. In June, Matisse began extending *The Parakeet and the Mermaid* beyond the corner of his bedroom onto the adjacent wall. In order to arrive at the best possible shape and position for the new leaf forms, he adopted what seems to have been an unusual procedure. He covered each new section of wall with tracing paper on which a pattern of images proposed for that section was traced. This allowed him to judge how the new section as a whole would relate to what had already been made. This may be seen in a photograph of the work (page 110), accurately dated to June 17, 1952.[49] At the same time this photograph was taken, Matisse was also working on *Acrobats* (Pl. 36), using for the two figures a pose developed from *La Chevelure*. This exuberant gestural pose has as long a history in Matisse's art as that of the seated Blue Nudes, being a variant on the image of a dancer that also goes back to *Bonheur de vivre*. Like *Blue Nude IV*, *Acrobats* shows the sign of considerable reworking and revision, and was accompanied by a considerable number of drawings (page 126) — evidence that it was a hard-wrought seminal image. It was crucial to what followed. A variant on this image completed *The Parakeet and the Mermaid*, in the form of the mermaid on the right-hand side.[50] This cut-out therefore refers in its figural as well as its organic imagery to Matisse's long-standing theme of the paradisal garden. Moreover, by recasting the primitive dancer as a mermaid, Matisse makes of this great mural not only a garden of fruits and plants and parakeet, but also an underwater garden that looks back to *The Beasts of the Sea*, and forward to *The Swimming Pool* (Pl. 27).

In completing *The Parakeet and the Mermaid*, Matisse had found a way of assimilating even so highly individual a sign as a figural image into the abstracted organic world established by his earlier cut-outs. He did so by flattening and simplifying the figural image to an equivalent level of abstractness as that of the organic signs. But he still acknowledged its very individuality. Matisse balanced its highly distinctive contours against the more regularized, and more easily readable, ones of the leaves and fruit. Only by restricting the number of such distinctive images did the work succeed, and then only by accepting a compositional rather than chromatic structure for the work as a whole. The situation was created in Matisse's art that when the signs do gel it is composition not color, and the spaces from which color is expelled, that holds them together.[51] Repeated signs, sharply contrasted against the white of the ground, affirm compositionally the flatness and tautness of the surface. Everything is accommodated to the surface and lies flatly on top of it. No volume-suggestive contours are therefore permissible. To be compatible with such a system, any sign for the figure had to become the shadow of a figure cast on the surface. In *The Parakeet and the Mermaid*, Matisse's cut-out method affirms its similarity to that of the silhouette. Imagery derived from the real world is projected into another dimension. The dimension is that of memory; the clearly defined images of this work are the static characteristic images of memory separated from the temporal flux of the passing world. The surface of the

picture becomes a plane parallel to nature, a sheerly mental space that receives the impressions of nature in remembered, idealized form.

No sooner, however, had Matisse arrived at this marvelously poetic manner of denoting a world of the imagination than he put it aside for something more dramatic, seeking to recover in the contours of figures that sense of implied volume and spatial movement necessarily banished from *The Parakeet and the Mermaid.* Using the image of the mermaid as a point of reference and departure, Matisse cut the first of the bathers for *The Swimming Pool* (Pl. 27). Like *The Parakeet and the Mermaid,* conceived as "a little garden," *The Swimming Pool* was explicitly environmental in motivation. "I have always adored the sea," he said with reference to this work, "and now that I can no longer go for a swim, I have surrounded myself with it."[52] As a decorative environment, *The Swimming Pool* complemented *The Parakeet and the Mermaid* on the walls of Matisse's apartment. *The Parakeet and the Mermaid* was made in the daytime in Matisse's bedroom; *The Swimming Pool* in the dining room, Matisse only working on it in the evening. One is multicolored, the other confined to blue and white against a beige ground, originally that of the dining room walls. Whereas the format of the earlier work evolved only gradually and its specific components were only finalized after much trial and error, the basic conception of *The Swimming Pool* was established from the start. The individual figures were developed sequentially, but Matisse clearly began with the whole general scheme in his mind since his first act was to sketch the large band of heavy white Canson paper around the entire room.

On this depends first of all the great drama and exhilaration of the work. "Shouldn't a painting, based on the arabesque, be placed on the wall without a frame?" Verdet had asked Matisse. "The arabesque is only effective," Matisse replied, "when contained by the four sides of the picture."[53] But he added a rider: "When the four sides are part of the music, the work can be placed on the wall without a frame." In *The Swimming Pool,* the containing edges are indeed a part of the design; the bathers leap in and out of the long, rectangular strip, its taut whiteness stretched out like an elastic band. Its narrowness, whiteness, and geometry only serve to accentuate the energy and abandon of the freely contoured blue forms.

By first establishing the frieze-like white band, Matisse also created the conditions for a new, far more organic method of composition than exists in any of the other cut-outs. The position and shape of each image was dictated by those preceding it on the unrolling panorama, with the result that the work appears to grow internally with one image generating the next in an almost narrative manner.[54] There was, therefore, for Matisse far less of a methodological division than usual between making and placing of images. The very composition of the work is an extension of the image-making process. By accepting a severely restrictive format—and then subverting it — Matisse was able to bring to a large-scale work the kind of internal surface development characteristic of his paintings, but only previously realized in cut-outs of single images, such as the seated Blue Nudes. Matisse in fact harnessed the different Blue Nude styles of 1952 and brought them together to create a conclusive work. It is not certain in which order the various figures in *The Swimming Pool* were made. However, Matisse probably began with the section to the right of the door (page 119). The early figures to the right of this section are gestural wholes like *Acrobats.* By the end of the section, contours are opened and forms are separated to admit white, as in *The Frog.* By the end of the second section, white stands not only for the water in which the bathers swim, but as with *Venus,* for their bodies too. Matisse here resolves what *The Negress* had begun: the absorption of even so psychologically holistic an image as the human figure into its surrounding space.

Photographs of *The Swimming Pool* in Matisse's dining room show it divided by *Women and Monkeys* in a recess above the doorway (pages 118–19). The figures of the women in this composition have been opened up from the relative compactness of their earlier state (page 114), which suggests that they were redesigned to complement the effect of *The Swimming Pool. Women and Monkeys* may have been completed as soon as the first section of *The Swimming Pool* was made. More likely, however, it awaited the completion of the larger work before its design was finalized. In any case, Matisse's use of a continuous silhouette for the two monkeys was prob-

ably an attempt to provide firmer architectural accents at the perimeters of the work; the second side of *The Swimming Pool* also marks a return to more complete figures.

That is to say, the second side does not directly extend the "decomposition" at the end of the first. Instead, it forms a complement and counterpoint to it, taking as its starting point the back-diving figure at the center of the first side. The break in continuity of the white band above that figure (the only such break in the entire composition) therefore serves as a notational point of reference, drawing one's attention to the motif or theme to which the new set of four relatively self-contained variations are related. The figure is significantly flattened for its first appearance in the new section, and therefore recalls its original source, *The Swimmer in the Aquarium* plate from *Jazz* (Fig. 11). That image was derived from the spectacle of a female swimmer in an aquarium that Matisse had seen on the stage of one of the large Paris music halls.[55] The relationship of *The Swimming Pool* to this source confirms the reading of part of the works as a view through the panoramic windows of an indoor pool into the water beyond. Where images cross the boundaries of the white strips, however, the reading is reversed, and the effect is of being inside the pool looking out to the windows that surround it. We are in fact asked to interpret sections of the white band in different ways according to the different postures the bathers assume. At times we are looking down into a pool, at others we are close to the surface, and at yet others we seem to be seeing a pool in cross-section. Figures are presented from above, from the water itself and from the side. Because of the organic nature of the composition, there is no sense of division between the different views. Nevertheless, the implicit visual warp of the white surface caused by the changes in viewpoint is part of the keen spatial tension of the work.

Whiteness finally dominates *The Swimming Pool*, or at least brings its narrative to a conclusion. In the final dramatic bather, the pose of the previous figures is reversed, Matisse's methods are turned inside out, and it is white itself, surrounded by color, that gives the bather its form. In the traditional sense, this figure is really without form. In its absence of body, it is unlike any object that exists in the world. Nor is it a shape, as are the earlier figures in *The Swimming Pool*. Space flows through it, melting it into the surrounding whiteness of which it is a part, but it is itself without shape or form — sheer emptiness. The cut edges that contain it give it their shape and the sense of form and volume that they imply, but our perception of these attributes is so purely optical and our experience of them so wholly mental that this blind spot swimming across our vision has the shape and form only of a mirage.

Matisse had written to his friend, André Rouveyre, in 1942 "that in the work of the Orientals the drawing of the empty spaces left around leaves counted as much as the drawing of the leaves themselves."[56] He told Verdet that in *The Parakeet and the Mermaid* such empty spaces gave a "white-atmosphere, a rare and impalpable quality" to the composition.[57] In the last section of *The Swimming Pool* and in works such as *Venus* (Pl. 37), this is taken a step further. Matisse carried the lesson he learned originally from Cézanne's watercolors to an audacious conclusion: the white surface of a picture can be made pictorial even when not covered with paint.[58] He brought to a climax the Symbolist concern with the still silence at the center of the work of art, as transmitted through Mallarmé's belief that "the intellectual core of the poem conceals itself, is present — is active — in the blank space which separates the stanzas and in the white of the paper: a pregnant silence, no less wonderful to compose than the lines themselves."[59] Matisse made his images out of this pictorially affective silence.

The creation of signs had brought with it a new reliance on memory rather than on direct observation. The distilled objects that Matisse was creating were mental images, things that existed "in something other than real space," only in the mind. Their whiteness, the "very pure, non-material light" that comprises them, is finally the light that Matisse had been seeking, "not the physical phenomenon, but the only light that really exists, that in the artist's brain." Having been realized, it expelled what had been Matisse's most preciously conserved gift, construction through color. Paint as such had already been forced aside; now color itself, and its ability to compose the whole surface of a picture, seemed relegated to a secondary role. The absence of multiple colors

is what gives *The Swimming Pool* its unity, combined with the restrictions placed upon the composition by the narrative, frieze-like form. At about this point, Matisse determined to force color back into a structural role in his immaterial mental world and made "the abstract panel rooted in reality" which he called *The Chromatic Composition* or *The Snail* (Pl. 38).[60] To give greater prominence to construction in color—the second, color-arranging, part of the cut-out process—Matisse minimized the first—image-creating—part. To do this, he used what are for him extremely neutral shapes: rectangles of color dispersed around a square format, an unusual one not only for Matisse but for all painting at this time.[61] It is as if at this moment either the first or the second part of the cut-out process must dominate the other for the work to absolutely succeed.

In *The Parakeet and the Mermaid*, the imagery is extremely limited, consisting of variations on two basic kinds of leaf forms, pomegranates, and the two figures. This reduced vocabulary places greater pressure on the syntax of the work; its success is in large part compositional. In *The Swimming Pool*, by contrast, the composition of the work is based on the image-making process. Methodologically, *The Snail* is closer to *The Parakeet and the Mermaid*. Its compositional order, however, is not based on a grid. Although its rectangular components and square shape implicitly refer back to a grid form, they do so only to subvert its regularity, thus giving color a free and mobile rein around the surface.

Using the same square format and similar rectangular shapes, Matisse turned to the last of his great cut-outs of 1952. Completed in 1953, *Memory of Oceania* (Pl. 39) is remarkable for the way in which the two parts of the cut-out process come together again. It is perceived as a picture precisely because image-making and construction in color are bonded together. Indeed, so are the most fruitful possibilities of the cut-outs of that whole year; images exist both as discrete shapes and as whites surrounded by color; color energizes the open white space; and the composition is at once geometric and free. Everything is informed by the sense of dazzling light, created by the relationship of colored papers and white ground suffusing the whole work. "The light of the Pacific, of the Islands, a deep golden goblet into which

you look" was one of Matisse's principal memories of Oceania, visited twenty-two years before.[62]

It was Matisse's deepening understanding of his art as a construction of colors which expressed light that provoked his visit to Tahiti in 1930, and which set him on the path that led to the cut-outs. He explained to Aragon how, better to appreciate the light and colors of the Tahitian islands, he would dive beneath the waters of the lagoon then suddenly raise his head into the brilliant sunshine.[63] The disposition of blues in *Memory of Oceania*, which gives the sense of a single sheet of color pulled apart to the edges of the work, recreates the experience of surfacing in front of what Matisse called "that isle of thoughtless indolence and pleasure."[64] We are once again returned to the vision of an ideal aquatic land. The water nymphs of *The Swimming Pool* are thus followed by an evocation of the kind of setting they might well inhabit. Matisse's 1935 tapestry design, *Window at Tahiti* (Fig. 22), was the source for the radically abstracted ship with fuscia-colored mast, green rectangular deck, and curved black mooring rope crossing the blue prow that dominates the right-hand side of the composition. The charcoal drawing toward the bottom of the cut-out probably denotes the waves of a Tahitian lagoon. The highly ambiguous area towards the upper left seems to refer simultaneously to a tree with fruit and to the figure of a woman seen from the back with prominently defined spine surmounted by yellow hair, raised left arm and curved right contour, with the left side of the body enclosed by white and the right side by blue. These fragmentary suggestions of sea, ship, and figure rising from the waves draw together important and persistent themes in Matisse's whole art. The work looks back even to *Luxe, calme, et volupté* (Fig. 23) of nearly fifty years before.

Memory of Oceania is therefore a decidedly retrospective work, looking to the idealized past for its theme and looking to the past in Matisse's art for its forms and iconography. In this it forms a complement to *The Swimming Pool*. Whereas *The Swimming Pool* refers back to the gestural forms of works like *Dance* (Fig. 14), the structural grandeur of *Memory of Oceania* looks back to Matisse's great experimental paintings of the teens, like *Bathers by a River* (Fig. 24). Just as the *Bathers*

completed in monumental form a sequence begun by the arabesques of *Dance*, so the disciplined calm of *Memory of Oceania* complements the fluid rhythms of *The Swimming Pool* and brings to a fitting conclusion the series of decorative evocations of an ideal land that Matisse had made throughout his career. This, arguably Matisse's last masterpiece, presents in distilled and contemplative form the geography of such a place.

No subsequent cut-out so thoroughly encapsulates the preoccupations of Matisse's whole art in fully pictorial terms. Whereas *Memory of Oceania* is perceived as a new species of picture, the cut-outs that followed it in 1953 take on an explicitly decorative character. The format of *Large Decoration with Masks* (Pl. 41) was possibly suggested by arranging some cut-out leaves around an old lavabo with a marble head that Matisse kept in his studio (page 125). In this work and in *Decoration, Fruits* (Fig. 25) and *Apollo* (Fig. 26) — all designs for ceramic commissions — which followed that same year, Matisse returned to the compositional format of *The Parakeet and the Mermaid*, which he was certainly still thinking about early in 1953, even if not actively working on it. (In January, he was as yet conceiving of it as two adjacent panels placed at right angles, much as it appears in photographs of his studio [pages 112–13].)[65]

In the new works, however, he codified this compositional method in a way that looks back to the most rigid of the earlier gridded cut-outs. In the cut-outs of early 1953, unlike *The Parakeet and the Mermaid*, everything is locked firmly into its separate part of the implied grid. *The Parakeet and the Mermaid* succeeded so well not only because the grid seems to dissolve even as we recognize it, but because the work suggests a narrative reading from the parakeet on one side to the mermaid on the other. The cut-outs of early 1953, in contrast, are organized by rigid and repetitive symmetry. This is modified by variations in the way similar quatrefoil groups are cut; but the works are still far more precisely ordered than the previous cut-outs.

In Matisse's later large-scale cut-outs of 1953, this effect is generally allayed. *The Wild Poppies* (Pl. 43), *Vine*, and *Ivy in Flower* (Pl. 44), all window designs, return in different ways to the methods of the earlier windows, as does Matisse's very last work, the rose win-

22. *Window at Tahiti*. 1936. Tapestry, 89″ x 68″.

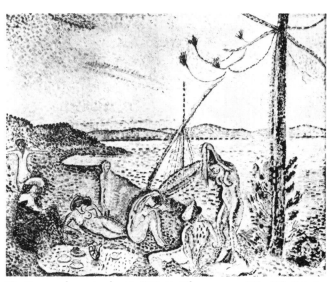

23. *Luxe, calme, et volupté*. 1904–5. Oil on canvas, 37″ x 46″. Private Collection, Paris.

24. *Bathers by a River.* 1916. Oil on canvas, 8′7″ x 12′10″. The Art Institute of Chicago, Chicago. The Worcester Collection.

25. *Decoration, Fruits.* 1953. Paper cut-out, 13′5⁷/₁₆″ x 28′6½″. Musée Matisse, Nice.

26. *Apollo*. 1953. Paper cut-out, 10'8¼" x 13'10½". Moderna Museet, Stockholm.

dow of 1954 (page 127). *The Negress* was completed in 1953 by the addition of quatrefoil patterns. It suggests something of an alternative compositional method; the more abstract leaf-derived forms seem to float from the compass of the figure into the surrounding white. Its effect is clearly seen in the graceful spreading movement of the beautiful and very ethereal *The Acanthi* (Pl. 45). However, none of these other works of 1953–54 involve quite the same redefinition of procedures as did the large decorations; they are, in consequence, far less problematic works. Although *Large Decoration with Masks* and its successors are literally the culmination of Matisse's experimentation with the cut-out medium, they are in ambition and in achievement somehow apart from the works that preceded them, and somewhat less for it — but particularly instructive for all that.

The *Large Decoration with Masks* (Pl. 41) suffers greatly in reproduction since its vast scale and its enveloping environmental effect cannot be appreciated. (Over thirty-two and a half feet in length, it is Matisse's second largest work on one plane after the Barnes murals.) Although in reproduction it seems far more inactive than it really is, it is basically an inactive work, static in its effect—and was conceived as such. Matisse had significantly different standards for his decorative commissions than for his pictures. He felt that the effect his decorative works produced on the observer should be unlike that of his paintings, even those of quite a considerable size. In describing these standards in relation to the cut-outs, we are faced with an obvious problem: all of the cut-outs, in their different ways, are decorative works. Understanding Matisse's decorative standards will help tie together the threads of the whole preceding discussion on the cut-outs, leading to the very heart of Matisse's achievement in this form.

Matisse himself was not afraid to use the word "decorative" in talking about his work. He used it to explain that he was interpreting nature, not just copying it ("I seldom paint portraits, and if I do, only in a decorative manner . . . "[66]) and also to describe how he composed his pictures: composition is "the art of arranging in a decorative manner the diverse elements at the painter's command to express his feelings."[67] This "decorative

manner" meant an all-over distribution of expressive interest across the picture surface so that emotion — Matisse's interpretive response to nature — did not merely reside in the individual objects depicted. Our empathy is invited not to the individual objects or figures within the picture but to the whole picture itself. "The entire arrangement of my picture is expressive . . ." Matisse insisted, "everything has its share."[68] There is a corollary to this: "In a picture every part will be visible and will play its appointed role, whether it be principal or secondary. Everything that is not useful in the picture is, it follows, harmful."[69] The work of art — where everything is expressive and no element can be dispensed with; where nature is possessed in images whose expressiveness cannot be separated from that of the picture as a whole — is necessarily dedicated to harmony as well as to unity. It is "an art of balance," but also "of purity and serenity, devoid of troubling or depressing subject matter . . . a soothing, calming influence on the mind, something like a good armchair which provides relaxation from physical fatigue."[70]

It has been pointed out that the so-called leisure criterion inherent in this passage—the implication that art should provide rest and relaxation for the viewer—links Matisse's aesthetic standards to those of the decorative arts.[71] It has also been suggested that the way these standards were made manifest—through a concern for the entirety of the flat planar surface of picture rather than subjects isolated in space—is also that of decorative art, of tapestry design and the like.[72] While acknowledging the influence of decoration on Matisse's style, the specifically "decorative" character of his art should not be exaggerated. With the exception of the large 1953 decorations, the uniformly patterned fields characteristic of decorative art are noticeably absent from Matisse's work. His frequent use of *areas* of repetitive patterning only emphasizes the freedom and symmetry of his com-

positional methods. In those instances where virtually the whole surface is patterned, as in the 1911 *Interior with Aubergines* (Fig. 15), the scale of patterning changes within the work. The 1911 still life sets a precedent for the cluster leaf forms of *Large Decoration with Masks*. The use to which the patterns are put — in the painting to create an ambiguous, shifting space for the eye to imaginatively enter and explore; in the cut-out to affirm a taut, continuous plane which acts as a barrier to the eye — shows us the difference between decorative painting and decoration.

The 1911 still life is one example of Matisse's rare use of a framing element before the time of *Jazz*. Although the painted border of the picture was later cut away, when seen with its border its "decorative" status is significantly increased. Nevertheless, it remains a picture. The richest of the cut-outs, like *Memory of Oceania* which also uses a border, have a very similar effect indeed: a marvelously ambiguous status between painting and decoration, but a fully independent status for all that, with not a hint of compromise involved. Significantly, the ambitious cut-outs that successfully use framing elements all evoke the feeling of paintings enough to exploit this ambiguity: they are all of "graspable" proportions, either uprights or squares; all are of a scale not beyond that which paintings can reasonably go; and all have the connotation of windows, which affirms their decorative status while referring back to the familiar open-window theme of Matisse's earlier paintings. When, however, framing elements are used primarily as containing devices — to arrest the development of a potentially infinite, repetitive field — they assume an architectural rather than a pictorial function. The cut-out pilasters at the sides of the large decorations enforce the metaphor of the wall these works present; walls are resistant surfaces incapable of being opened like windows to the viewer's imagination. They in fact do the very opposite: the decorations covering their surfaces project themselves into the viewer's space.

The taut resistant flatness that appeared at the end of Matisse's career needed to be marked out and separated as something pictorial more urgently than did the airy breathing surfaces of his earlier work. There, the surface yielded to the eye, letting it penetrate into the painting. This flatness stops the eye short. It can spread out almost without limit. Symmetry was one method of containing it, but not the most successful: the implied narrative reading across *The Parakeet and the Mermaid* and the internally active frame of *The Swimming Pool* seem far less imposed structures. The fact that Matisse was no longer using paint but pure color made flatness a particular problem. When painting, he did not have to bring the elements of the picture together solely by means of composition or chromatic balances. He could layer the color and let the ground that breathed through bring everything together. This, of course, was not possible with the cut-outs, and, as we have seen, Matisse only achieved an analogous effect when he let white have its full sway, and contained the colors within its orbit. Even then, however—as we have also seen—the whites sometimes rejected the colored shapes by virtue of their very specificity. This was likely what caused Matisse to use similar repeated shapes in the large decorations.[73] The result of this, however, is that the repetition of similar shapes is what organizes these works; although they contain a multiplicity of colors, their order is not a chromatic but a compositional one. Strangely enough, the more Matisse's work tended toward decoration, both in conception and in scale, the less fundamental to its organization became that one component of all art, color, that had long seemed to be the most affirmatively decorative.

Matisse, more than anyone else, changed this understanding of color. For him, color was not the special locus of the decorative in art; all elements of a work of art contributed to its decorative totality. What was new and important about Matisse's understanding and use of color was that he made it an agent of expression in a way it had never quite been before. He saw in the decorative arts, as well as in certain non-European arts, how central a role color could have in picture-making—but only if it were retrieved from decoration, not further entrenched in the decorative, as is too often supposed. Matisse retrieved color from the decorative arts for picture-making, and thus retrieved color in picture-making from a secondary role. Of course, color had long been used as far more than a decorative embellishment to form. However, almost right up to Fauvism, it was still in the drama

of black and white that stories were told and the world modeled and given shape. In such a context, color might heighten the drama (although more often it tended to neutralize it), it might "clothe" form, and even at times dissolve it. But, while the tonal armature of painting remained, color could not actually constitute form or emerge as a principal medium of expression.[74]

Matisse liberated color from the black-and-white axis more completely than any earlier painter. The drama of black and white was replaced by the drama of contrasting frank and discrete hues, each often at full intensity and balanced not as tonal accents but as chromatic ones. Once this happened, the black-and-white axis became a way of modulating the expression of color, just as, earlier, color had inflected and varied the expression of modeled form. As color had softened the drama of black and white in decoration, where drama was out of place, so black and white—and a tonal armature of surface patterning—brought restraint to color in Matisse's decorative projects. In the Barnes murals, Matisse's color is severely muted. In the *Jazz* portfolio and at Vence, black-on-white calligraphy and drawing offset and complement the pure color. The surfaces of large decorations are ordered by repeated shapes contrasted in value to the white grounds, not by the expressive order of color. Matisse, in these instances, does not in fact draw in color but designs with color. The principle at work here is better characterized as ornamental rather than decorative: abrupt but regularly repeated contrasts of light and dark enforce a still, patterned all-overness of effect in which color and expression are tempered together.[75]

The kind of expressive restraint the decorations particularly reveal Matisse often claimed for his entire art. Its effect was to be restful and relaxing. We may want to applaud Matisse for claiming only so much for what his work could achieve; sheer experience of his art, however, proves it to be doing much more.[76] The experience is far more than a passive one. True, by insisting that art is only refreshing—just as by insisting that it is decorative—he is able to characterize its pleasure as aesthetic, disinterested rather than purposeful. Aesthetic perception, however, is not a passive act, and the experience of Matisse's art could not be further from the sensation of

sinking into "a good armchair." Looking at the paintings and at the most "pictorial" of the cut-outs, one is invited to imaginatively enter their separate worlds, worlds other than the one we inhabit, parallel to our own but set apart and exhilarating in their apartness. Matisse not only recognized but required that they be looked at in this way. "A picture is like a book," he wrote, "its interest does not overwhelm the spectator who must go in front of it."[77] Then he corrected himself: "I should have written 'in search of' [it]." "Like the book on the shelf of a bookcase . . . it needs, to give up its riches, the action of the reader who must take it up, open it, and shut himself away with it—similarly, the picture enclosed in its frame . . . cannot be penetrated unless the attention of the viewer is concentrated especially on it."[78] This, he said, is essentially different from the experience of "architectural painting," a term we must extend to include the large decorative cut-outs, where the work is coexistent with the viewer. Active, concentrated attention, Matisse says, is inappropriate to art of this kind. Only in such instances does perception become truly passive, and the work completely "a soothing, calming influence on the mind."

It is in works of this kind that artists must be particularly careful not to "weigh down their walls" with expression, Matisse wrote.[79] In consequence, "the human element has to be tempered, if not excluded . . . the spectator should not be arrested by this human character with which he would identify." This is, of course, highly relevant to the way in which figures disappear from the cut-outs as they tend toward decoration and reappear as they come closer to painting. Matisse continues, however: architectural or decorative work should provide "the atmosphere of a wide and beautiful glade filled with sunlight, which encloses the spectator in a feeling of release in its rich profusion. In this case, it is the spectator who becomes the human element of the work."

This is the manifesto of an affirmatively situational art. This characteristic, perhaps more than any other, separates decoration from painting and expresses the different standards Matisse brought to each enterprise. The spectator experiences the decorations in situational terms as part of an environment that encloses and absorbs him. This is not entirely attributable to their size.

Physically, *The Swimming Pool* is by far the largest and the most explicitly environmental of the cut-outs, yet it escapes the situational quality because it does not confront and invite the complicity of the viewer as the large decorations do. Its self-generating internal narrative assures its pictorial independence by distancing the viewer as painting traditionally does. In the case of the large decorations, the space occupied by the viewer is not separate from, but is coexistent with, the work in question. The experience tends to be that of an architectural not a pictorial space. Painting and decoration were two conflicting poles around which the cut-outs were made. In every work, the two impulses are present, in differing proportions. At times, they come perfectly together, but they are different for all that.

This is not to say that the expressive restraint particularly demanded by decoration was not a part of Matisse's painting as well. It belongs to his whole art. Matisse's aesthetic theories do bear comparison with certain nineteenth-century teachings on decoration.[80] However, both derive from a common source in French academic principles and have their ultimate origin in the classicist tradition. The notion that painting must give pleasure to the eye, that the ugly must be concealed and the eye not distracted by the unexpected or improbable, and that the beauty of a work of art be the ideal beauty of distillation, superior to corporeal reality can be traced back to the *Della Pittura* of Alberti, and even further back to Alberti's Greek sources; so too can the rejection of mere copying and the insistence on a complete and exact harmony of the parts of the design. Where Matisse separates himself from this heritage—in his repudiation of the civic, didactic, mathematical, and moralistic—he does so only to ally himself to another long-standing tradition: a tradition of poetic and pastoral art. Since the Renaissance, this kind of Arcadian painting was thought to be similar to music in its effect on the human mind, and able to "help restore the tired spirits of the man of affairs."[81] The pastoral subject, being suggestive rather than didactic in presentation, countenanced an art not tied to specific meanings but dedicated to the evocation of universal harmony. Because of its suggestiveness, it was particularly open to technical experiment, tending to the sensual, the lyric, and the instinctive. Matisse

rediscovered the pastoral mode for the twentieth century. He eventually transposed his pastoral from the traditional landscape-as-garden to bourgeois settings, but his art always remained one of luxury, calm, and voluptuousness. The final transformation of his art through the cut-outs confirms this. Matisse returned to the image of the Arcadian garden. Tendrils and the teeming profusion of organic things dominate most of the cut-outs. When figures appear, they either relax in decorative poses or float free of the gravity of the literal world, distanced and apart in the world of Matisse's imagination. Often, it is a primeval undersea world, and therefore even more distanced from contemporary reality. Oceania, the beasts of the sea, swimmers, the garden surrounding the water, animals and plants: this is Matisse's world in the art of his last years.

Removed from everyday reality, Matisse's art imposes its own order and enforces its own reality. Turning away from common experience allowed Matisse great pictorial license. He actually required such license, if the style of presentation was to match the extraordinary subject matter. The style had to be as lyric and suggestive as its subjects, and yet as direct: frank and open in its technical means. One of Matisse's most important contributions to twentieth-century painting was his insistence that candor, both in address and in handling, was necessary to such a lyric art—and that this candor was best realized when color was allowed to dominate pictorial art. This in turn meant unconstricted composition and a breathing, open surface. In the cut-outs, color finds its absolute purity, separate even from paint; the whiteness of the surface breathes around the pure color; and the method of creation and composition is as direct and candid as Matisse ever allowed. Of course, the new directness that Matisse found in the cut-outs was not without its risks. We miss at times the visible evidence of struggle. In some works, the purification and the reduction of means seems to simply produce less. And reduction of means could sometimes lead not to purification but to an embellishment of the means that remained. Filigrees and tendrils obviously fascinated Matisse, and sheer scissor-virtuosity was sometimes hard to resist. However, the distillation Matisse attempted, and for the most part succeeded in creating in his late work was truly

remarkable. It was distillation not only of his direct responses to the natural world, not only of the formal elements of pictorial art, but of the entire set of premises, both formal and iconographic, that had been cumulatively developing in his own art for some fifty years. Medically a dying man, Matisse was reviewing his whole artistic life, and building around himself emblems of the world his art had continually explored.

Matisse's world is an earthly paradise, yet it is not simply an escapist world. It escapes contemporary suggestion only in search of a kind of equilibrium, permanence, and instinctiveness that contemporary subjects could not provide. It is, in one sense, a search for innocence in an age of experience. Even more, it is a search for a way of representing a private vision with a potency that defeats the actual; an attempt to make something more exact to inner experience than discursive explanation; and a struggle for the kind of self-possession that would allow art to seem self-possessed, self-contained with an internal equilibrium entirely its own. These are all Symbolist concerns. Matisse, how-ever, was able to realize what his Symbolist ancestors never fully achieved, an art where "the end is not distinct from the means, the form from the matter, the subject from the expression; they inhere in and completely saturate each other."[82]

Matisse's whole development appears in retrospect as a version of that central Symbolist image: the journey to an ideal land, a land that mirrors the temperament of the traveller. In making this real in each of its representations, Matisse was realizing himself. His last works, the cut-outs, with their pastoral subjects and their distilled signs "filtered to the essentials," fixed in a non-material, mental space were final acts of idealization and realization at one and the same time. They ordered the world as Matisse had invented it and ordered his own feelings in his art. "It was always," he said, "in view of a complete possession of my mind—a sort of hierarchy of my sensation — that I kept working, in the hope of finding an ultimate method."[83] The ultimate method was that of the cut-outs—but only because it was the last. It was the kind of journey that could have gone on forever.

NOTES

Wherever possible, English language sources are given with original ones, which are then provided in abbreviated form along with references (at the first time of mention) to the Bibliography where full details of publication may be found. In the case of translated quotations, there may be differences between the versions here and the English sources to which the reader is directed. The author has modified certain translations in the interest of clarity or accuracy but for the convenience of students, prefers to indicate wherever material is readily available in English.

References to certain basic works have been made throughout in the following abbreviated form:

Barr: Alfred H. Barr, Jr. *Matisse: His Art and his Public* (New York: The Museum of Modern Art, 1951).

Flam: Jack D. Flam. *Matisse on Art* (London and New York: Phaidon, 1973).

Fourcade: Dominique Fourcade, ed. *Henri Matisse. Écrits et propos sur l'art* (Paris: Hermann, 1972).

St. Louis–Detroit: The St. Louis Art Museum and The Detroit Institute of Arts. *Henri Matisse. Paper Cut-Outs,* 1977.

1. Matisse, "Témoignages," 1952 (bibl. 13); Flam, p. 137.
2. Verdet, *Prestiges de Matisse,* 1952 (bibl. 25); Flam, pp. 142–147; St. Louis–Detroit, p. 282.
3. See St. Louis–Detroit, cat. 182, for discussion of this work. Virtually all of the cut-outs I mention are catalogued and discussed in the St. Louis–Detroit publication, certainly the most important study of the cut-outs to date and the foundation for all subsequent study. I am deeply indebted at many points to the scholarship of its authors (see note, bibl. 71); of course, responsibility for the interpretations, both aesthetic and historical, advanced here is entirely my own.
4. Verdet, *Prestiges de Matisse,* 1952; Flam, p. 144.
5. *Jazz,* 1947 (bibl. 17); Flam, p. 112.
6. See Flam, pp. 110–113; and Flam's discussion of this introduction as part of his essay "Jazz," in St. Louis–Detroit, pp. 43–45.
7. Cited by Dominique Fourcade, "Autres Propos de Matisse," *Macula* I (1976), p. 114.
8. See Jack Cowart, "Introduction," in St. Louis–Detroit, p. 17.
9. Matisse to Lejard, 1951, in Fourcade, p. 243.
10. Matisse, "Témoignages," 1952; Flam, p. 136.
11. Jacques Guenne, "Entretien avec Henri Matisse," 1925 (bibl. 10); Flam, p. 55.
12. Matisse to Fr. Couturier, 1948 in Fourcade, p. 242, n. 8.
13. This characteristic of Matisse's art is stressed by Fourcade in his stimulating essay, "Something Else," in St. Louis–Detroit, pp. 51–52, 54. See also the fine appreciation of Matisse's Nice period in Jane Livingston's "Matisse's 'Tea'," *Los Angeles County Museum of Art Bulletin* XX, 2 (1974), pp. 47–57.
14. "Entretien avec Tériade," 1930 (bibl. 22); Flam, p. 60.
15. Flam, p. 60.
16. Ibid. p. 63. Fourcade stresses the importance of Matisse's experience of American light, but exaggerates, I think, in seeing the grounds of the cut-outs as direct analogies of that harsh whiteness (St. Louis–Detroit, pp. 54–55).
17. Tériade, "Constance du fauvisme," 1936 (bibl. 23); Flam, p. 74.
18. See Flam in St. Louis–Detroit, p. 46 n. 4 for details of the works of this period for which in-process photographs have been published.
19. Jean Clair, ed., "Correspondance Matisse-Bonnard (1925/46)," *La Nouvelle Revue Française* XVIII, 211 (July 1970), p. 92.
20. Quoted by Barr, p. 256.
21. Letter of 16 January 1942 in Fourcade, p. 288.
22. "Matisse-en-France," 1943 (bibl. 1); Flam, p. 95.
23. Clara T. MacChesney, "A Talk with Matisse," 1913 (bibl. 14); Flam, p. 51.
24. "Notes d'un peintre," 1908 (bibl. 15); Flam, p. 37.
25. Flam, p. 37.
26. "Témoignages," 1952; Flam, p. 137.
27. Quoted by Pierre Schneider in his introduction to *Henri Matisse Exposition du Centenaire* (Paris: Grand Palais, 1970), p. 46.
28. Verdet, *Prestiges de Matisse,* 1952; Flam, p. 147.
29. Letter to Rouveyre, 22 February 1948 in Fourcade, p. 243.
30. "Rôle et modalités de la couleur," 1945 (bibl. 4); Flam, p. 100.
31. See Flam, "Jazz," St. Louis–Detroit, pp. 42–43.
32. Letter to Rouveyre, 28 December 1947. Quoted by Schneider, *Henri Matisse Exposition du Centenaire,* p. 48.
33. The only true precedents are Matisse's 1911 *Interior with Aubergines* mentioned earlier and the *Rouge et Noir* and occasional *Verve* cut-outs of 1937–38 (See St. Louis–Detroit, cat. 3–8).
34. The iconography of this work is discussed in Jack Cowart, "Matisse's Artistic Probe: the Collage," *Arts Magazine* 49, 9 (May 1975), pp. 53–55.
35. Matisse considered *Sorrow of the King* "equal to all my best paintings." (See St. Louis–Detroit, cat. 166). None of the previous cut-outs had been described in these terms.
36. "Notes d'un peintre," 1908; Flam, p. 38. Despite this statement, however, many of Matisse's highly successful works — and not only cut-outs — do not use the human figure.
37. Letter to Alexandre Romm, 14 February 1934 in Flam, p. 68.
38. St. Louis–Detroit, p. 211.
39. The evidence on which the chronology of Matisse's art is based is collected in the Appendix at the end of these notes.
40. This work is discussed in detail in Elderfield, *Matisse in the Collection of The Museum of Modern Art* (New York: The Museum of Modern Art. 1978), pp 158 ff.
41. "Témoignages," 1952; Flam, p. 137.
42. St. Louis–Detroit, cat. 170.
43. See the author's discussion of *Blue Nude I* in his *European Paintings from Swiss Collections. Post-Impressionism to World War II* (New York: Museum of Modern Art, 1976), p. 76.
44. See John Hallmark Neff, "Matisse, His Cut-Outs and the Ultimate Method," St. Louis–Detroit, pp. 26–28 for a fine discussion of the sculptural aspects of the cut-outs.
45. See William Tucker, "Four Sculptors, Part 3: Matisse," *Studio International* 180, 925 (September 1970), p. 87; and Elderfield, *European Master Paintings,* p. 76.
46. Matisse to Courthion, reported in Jean Guichard-Meili, *Henri Matisse, son Oeuvre, son Univers* (Paris: Fernand Hazan, 1967), p. 168.
47. *Prestiges de Matisse,* 1952; St. Louis–Detroit, p. 282.
48. St. Louis–Detroit, cat. 167.
49. I am indebted here to John Rewald's scrupulous records for the date of this photograph, and for information on the contents of Matisse's work rooms and on his working procedures.
50. The mermaid image looks back ultimately to a series of ten *Sirènes* lithographs that Matisse made in 1942. See *Lithographs and Aquatints by Henri Matisse* (Beverly Hills, California: Frank Perls, 1969).

51. Fourcade points to the nonchromatic structure of many of the cut-outs in "Something Else," St. Louis–Detroit, p. 53.

52. Statement recorded by Mrs. Alfred Barr, in the files of The Museum of Modern Art. The development and iconography of *The Swimming Pool* is discussed in detail in Elderfield, *Matisse in the Collection of The Museum of Modern Art*, pp. 162 ff.

53. *Prestiges de Matisse*, 1952; Flam, p. 143.

54. St. Louis–Detroit, cat. 177.

55. Ibid., cat. 28.

56. Fourcade, p. 168.

57. *Prestiges de Matisse*, 1952; Flam, p. 144.

58. See Elderfield, "The World Whole: Color in Cézanne," *Arts Magazine*, April 1978, pp. 148–153.

59. As Dore Ashton points out ("Matisse and Symbolism," *Arts Magazine*, 49, 9 [May 1975], pp. 70–71), Matisse maintained a lifelong interest in Mallarmé's poetry and clearly emerged from a Symbolist background himself.

60. St. Louis–Detroit, cat. 198.

61. John Jacobus, *Henri Matisse* (New York: Abrams, 1972), p. 180.

62. Verdet, *Prestiges de Matisse*, 1952; Flam, p. 145. See also Elderfield, *Matisse in the Collection of The Museum of Modern Art*, pp. 169 ff., where the sources and iconography of this cut-out are discussed in detail.

63. Louis Aragon, *Henri Matisse: a novel* (London: Collins, 1972), p. 8.

64. Ibid., p. 9.

65. Letter to Pierre Berès, 20 January 1953 in St. Louis–Detroit, p. 281.

66. MacChesney, "A Talk with Matisse," 1912; Flam, p. 52.

67. "Notes d'un peintre," 1908; Flam, p. 36.

68. Flam, p. 36.

69. Ibid.

70. Ibid., p. 38.

71. Joseph Masheck, "The Carpet Paradigm: Critical Prolegomena to a Theory of Flatness," *Arts Magazine* 51 (September 1976), pp. 82–109.

72. See especially John Hallmark Neff's important studies on this subject: "Matisse and Decoration, 1906–1914: Studies of the Ceramics and the Commissions for Paintings and Stained Glass," Ph.D. dissertation, Harvard University, 1974; "Matisse and Decoration: An Introduction," *Arts Magazine* 49, 9 (May 1975), pp. 59–61; 49, 10 (June 1975), p. 85; "Matisse and Decoration: The Shchukin Panels," *Art in America* 63, 4 (July-August 1975), pp. 38–48; "Matisse, His Cut-Outs and the Ultimate Method," St. Louis–Detroit, pp. 21–35.

73. It is tempting to view this organization as a direct result of the ceramic tile format Matisse was planning for. Neff's comparison with the mosaics of the Alhambra, Granada (St. Louis–Detroit, p. 32) would seem to support this. Nevertheless, Matisse had earlier made an important tile mural—for the Vence chapel—where the design is quite negligent of the grid pattern produced by the tiles (see Barr, p. 520). There were clearly other than technical reasons for Matisse's use of an explicit grid.

74. I am borrowing here certain remarks originally made in the context of Cézanne, who began that liberation from the black-and-white axis which Matisse completed. See Elderfield, "Color in Cezanne," pp. 149–150.

75. For the useful distinction between decoration and ornament, see Clement Greenberg, "Detached Observations," *Arts Magazine* 51, 4 (December 1976), pp. 88–89.

76. Clement Greenberg, "Influences of Matisse" in *Henri Matisse* (New York: Acquavella Galleries, Inc., 1973).

77. Letter to Alexandre Romm, 14 February 1934 in Flam, p. 69.

78. Letter to Alexandre Romm, 17 March 1934 in Flam, p. 70.

79. See letter to Romm, 14 February 1934, in Flam, p. 69.

80. Neff, "Matisse and Decoration: An Introduction," *Arts Magazine* 49, 9 (May 1975), pp. 59–61.

81. This is not Matisse, but Alberti as paraphrased by E. H. Gombrich in his "The Renaissance Theory of Art and the Rise of Landscape," *Norm and Form. Studies in the Art of the Renaissance*, 2nd ed. (New York: Phaidon, 1971), p. 14. Both this essay and "Leonardo's Methods for Working Out Compositions," also in *Norm and Form*, are relevant to this discussion, which I first advanced in relation to Matisse's art in "Morris Louis and Twentieth-Century Painting," *Art International* XXI, 3 (May-June 1977), pp. 24–32.

82. This is Pater's famous passage on the aspiration of the arts to the condition of music, quoted here from Frank Kermode's important and fascinating *Romantic Image* (London: Routledge and Kegan Paul, 1961), p. 65, which is of extreme relevance to the argument advanced here.

83. Matisse to Courthion in Guichard-Meili; *Henri Matisse*, p. 168.

APPENDIX

In 1952, Matisse's work in cut-outs reached its climax as he drew together what he had learned over the previous twenty years. By and large, his stylistic development before 1952 can be followed with comparative ease. Certainly, the order in which the cut-outs were made in any given year is not of the same critical interest it becomes in 1952 when Matisse worked in a number of different styles. The notes which follow below present the evidence on which the chronology for 1952 given in the text is based.

Information supplied by *Life* magazine to The Museum of Modern Art tells us that *Nuit de Noël* (Pl. 30) was formally commissioned by *Life* (after preliminary negotiations) on January 15, 1952. It was the first major work of the year. Photographs in the files of The Museum of Modern Art (see p. 109) taken under Matisse's direction and dated by Matisse's assistant, Mme. Lydia Delectorskaya, show that it was begun immediately following the commission and completed by February 27.

On April 9, Matisse wrote to Jean Cassou to thank him for his comments on *Sorrow of the King* (Pl. 31). (See St. Louis–Detroit, cat. 166.) This suggests that this work was completed certainly no later than the end of March.

On March 19, Gotthard Jedlicka interviewed Matisse (see Four-cade, "Autres Propos," pp. 113–114). Matisse discussed *Nuit de Noël* and then referred to a blue parakeet as his most recent cut-out. Jedlicka describes seeing cut-outs of leaves, some like hands with fingers. These were very likely some of the leaf-forms which, with the blue parakeet and the blue mermaid (made later), eventually made *The Parakeet and the Mermaid* (Pl. 34). However, evidence presented below suggests that this work had only recently been begun at the time of the Jedlicka interview and probably did not extend beyond the corner of Matisse's bedroom beside which the first leaves and the parakeet were placed (see p. 110–13).

The photograph of Matisse's studio (p. 121) shows that the figure in *The Negress* (Pl. 40) was completed when the first of the four seated Blue Nudes, *Blue Nude IV* (Pl. 35) (visible in the mirror in the photograph) was still being worked on. Internal stylistic evidence suggests that the seated Blue Nudes were made before any of the other blue figural cut-outs (see text, above). Since some of the blue figural cut-outs were tried out in *The Parakeet and the Mermaid* (St. Louis–Detroit, cat. 183), the photograph was taken well before *The Parakeet and the Mermaid* was completed—because the blue figures tried out in that work were not yet in existence. Another photograph of *The Negress* in the same state originally appeared in Verdet, *Prestiges de Matisse*, p. 33. Verdet interviewed Matisse in April and May of 1952. Although illustrations for Verdet's book could easily have been collected later in 1952 (its date of publication), it is certain that the work was in this state at the time of the Verdet interviews because Verdet reports seeing the seated Blue Nudes and the women of *Women of Monkeys* all of which were made after *The Negress* reached its initial state. It seems likely, therefore, that after just beginning *The Parakeet and the Mermaid* in his bedroom in March, Matisse turned to *The Negress* in his studio and brought it to its early state by about the end of that month. He then turned to the seated Blue Nudes, made therefore in April, which were followed by the other blue nudes that Verdet saw. Since *Blue Nude IV* took two weeks to make, being begun before the other three but completed last (St. Louis–Detroit, cat. 170), it is likely that the second series of Blue Nudes was only begun toward the end of

April, or in May.

Verdet also reports seeing *The Parakeet and the Mermaid*. This, however, was certainly still in an early state because when John Rewald was photographed in front of the mural on June 17, 1952, (p. 110) it had not been carried very far along the wall adjacent to that on which it was begun. At the time this photograph was taken, the following cut-outs were already in existence in the studio (see p. 114): the women of *Women and Monkeys*, *The Frog*, *Venus*, *La Chevelure*, *The Bell*, *Woman with Amphora and Pomegranates* (early state) and *Woman with Amphora* (early state). Also in the studio were the four seated Blue Nudes, while *Acrobats* (Pl. 36) was still in progress, the left-hand figure having been completed while the other was still incomplete. (Since the right-hand figure shows signs of considerable reworking, Matisse had probably begun with that figure, turned to the other and completed it, then gone back to the original image, as he did when making the seated Blue Nudes). In the bedroom, the only visible cut-out, apart from the early state of *The Parakeet and the Mermaid*, was *Blue Nude with Green Stockings*. *Nuit de Noël* had been moved into Matisse's living room.

After completion in Matisse's bedroom on February 27, *Nuit de Noël* had been moved along the wall to beside the door in order to make room for a new project, a series of drawings of heads which viewed together perhaps suggested to Matisse the repetitive-image format of *The Parakeet and the Mermaid* (see p. 111). The photographs of Matisse's bedroom with *The Parakeet and the Mermaid* nearing completion (p. 113) show *Nuit de Noël* back beside the door. It is obvious that these photographs were taken later than the June 17 photograph (p. 110). Given the advanced state of *The Parakeet and the Mermaid*, they probably date to July, by which time the women of *Women and Monkeys* had been moved from the studio to the bedroom to be tried out as part of the mural (see p. 112). It is clear that Matisse did not cut the image of the mermaid which completed the mural immediately after finishing the *Acrobats* (from which its pose derives) in June, but only turned to this image after rejecting other stylistic options, including that of "open" figures like *The Frog* and negative ones like *Venus*, both of which options were open to him since these works predate the mermaid. Matisse did not move from the seated Blue Nudes to continuously silhouetted figures, then to "open" and then to negative ones as stylistic analysis alone might easily suggest. He created a vocabulary of different stylistic forms from which he drew as the occasion demanded.

The development within *The Swimming Pool* (Pl. 27) from whole to open to negative images should not therefore be seen as a process of intuitive stylistic invention but as a series of deliberated choices from the different styles that were already in existence. The images themselves, however, would seem to have all been created within the context of this specific work—with one possible exception. The image to the immediate left of the doorway (see p. 118) may have originally been made as an independent cut-out. Verdet published it in 1952 as *La Plongeuse*, September 1952, and in his discussion of it made no reference to its having any companions (*Prestiges de Matisse*, pp. 97–98). If it was in fact made before Matisse conceived *The Swimming Pool* as a whole, this would help to explain why it interacts far less with its neighbor than the rest of the figures do with theirs, and would also reinforce the interpretation of *The Swimming Pool* as two complementary sections: one, begun with this motif, treated as a set of four relatively separate variations; the other, a single flowing movement with a variation on this motif at the center.

The Swimming Pool had not been begun when John Rewald visited Matisse on June 17, 1952. It was complete, however, when Mr. and Mrs. Alfred Barr made their visit in September of that year—by which time Women and Monkeys was in place across the doorway that divides the mural (p. 119). The monkeys were obviously added with this specific site in mind since they are mounted on a paper different than that the women are mounted on, and the completed composition exactly filled the recessed lintel space. Further, since the extended arm of the woman on the right carries onto the added sheet that contains the right-hand monkey, it is reasonable to assume that the modifications Matisse made to the women beyond the July state (p. 112) were also made in the context of the new site.

It is known that Matisse worked on The Swimming Pool only in the evenings (Mme. Lydia Delectorskaya to John Neff). Since the Barrs also saw Memory of Oceania (Pl. 39) and The Snail (Pl. 38) in September, these two works were presumably also begun in the summer of 1952. Both are dated 1953, which was likely when their forms were fastened down. They were apparently placed temporarily in Matisse's studio as the wings of a triptych with Large Decoration with Masks (Pl. 41) (begun end of January 1953) at the center (St. Louis–Detroit, cat. 199). Around the same time, Matisse was considering how best The Parakeet and the Mermaid should be mounted, and in a letter of January 20, 1953 (St. Louis–Detroit, p. 281), proposed a two-panel arrangement which would have duplicated the effect of the work carrying around the corner of his studio (p. 112). Also around this same time, Matisse returned to work on The Negress. The photograph reproduced on p. 122 shows the cut-out in exactly the same state it was in April 1952 (p. 121). Visible in the later photograph is Large Decoration with Masks at an advanced state which dates this photograph as no earlier than February 1953. The Large Decoration with Masks is seen in an earlier state in the photograph on p. 124, surrounded by cut-outs that had been made before the end of June 1952 (c. f. p. 114). Only after virtually completing Large Decoration with Masks, then, did Matisse return to work on The Negress. Later in-progress photographs of The Negress (p. 123) definitely confirm that Matisse only arrived at the final configuration of this work by introducing square sheets containing four-leaf patterns such as he had used in the Large Decoration with Masks. Since Large Decoration with Masks (and Decoration, Fruits; Fig. 25) preceded Apollo (Fig. 26), which was completed by May 1953 (St. Louis–Detroit, cat. 205), all these large decorative works were finalized in the early spring of 1953. All of Matisse's great environmental cut-outs were therefore produced between the spring of 1952 and the spring of 1953, in the space of a single astonishingly productive year.

BIBLIOGRAPHY

The literature on Matisse and his artistic context is considerable. This bibliography is highly selective, listing only the more useful references, both on Matisse's art as a whole and on the cut-outs — with particular reference to works used in the preparation of this study and on recent publications. For fuller listings of works up to 1951, the reader is referred to the bibliography in Alfred H. Barr, Jr., Matisse: His Art and his Public (bibl. 30); for works up to 1973, to that in Jack D. Flam, Matisse on Art (bibl. 6); and for works with particular bearing on the cut-outs, to the bibliography in Henri Matisse: Paper Cut-Outs (bibl. 71).

The entries given here, annotated at times to give some indication of their usefulness, are arranged alphabetically by author or publishing institution within each of the following groupings: A. Writings by Matisse; B. Books and Catalogues on Matisse; C. Articles on Matisse; D. Books and Catalogues on the Cut-Outs; E. Articles on the Cut-Outs.

A. Writings by Matisse

1. Aragon, Louis. "Matisse-en-France." In Henri Matisse dessins: thèmes et variations. Paris: Martin Fabiani, 1943. Reprinted, with other statements by Matisse, in bibl. 26. An important discussion of pictorial signs.

Barr, Alfred H., Jr. Matisse: His Art and his Public. 1951. See bibl. 30.

2. Clair, Jean, ed. "Correspondance Matisse-Bonnard (1925/46)." La Nouvelle Revue Française XVIII (July 1970):82–100; (August 1970):53–70.

Critique, revue générale (May 1974). See bibl. 32.

3. Diehl, Gaston. "La leçon de Matisse." Comoedia 146–147 (April 1944):1ff. Statements on Jazz.

4. _____ . "Rôle et modalités de la couleur." In Problèmes de la peinture, pp. 237–40. Paris: Confluences, 1945.

5. _____ . "A la recherche d'un art mural." Paris, les arts, les lettres 20 (19 April 1946):1–3. Statements on the Barnes Murals.

6. Flam, Jack D. Matisse on Art. London and New York: Phaidon, 1973. An exhaustive and well-annotated collection of forty-four of Matisse's longer, important writings and statements, with a useful general introduction to Matisse's career. The only English-language anthology, it is complemented by Fourcade's book (bibl. 7).

7. Fourcade, Dominique, ed. Henri Matisse: Écrits et propos sur l'art. Paris: Hermann, 1972. Also an exhaustive and well-annotated collection, but with more attention paid to Matisse's important occasional remarks than in Flam (bibl. 6).

8. _____ . "Autres Propos de Matisse." Macula I (1976):92–115.

9. Giraudy, Danièle, ed. "Correspondance Henri Matisse–Charles Camoin." Revue de l'Art 12 (Summer 1971):7–34.

10. Guenne, Jacques. "Entretien avec Henri Matisse." L'Art vivant 18 (15 September 1925):1–6. Also incorporated into his Portraits d'artistes (Paris: Edition Marcel Scheur, 1925), pp. 205–219.

11. Guichard-Meili, Jean. Henri Matisse, son Oeuvre, son Univers. Paris: Fernand Hazan, 1967. Includes some unpublished quotations.

12. Lejard, André. [Interview with Matisse] Amis de l'Art n.s. 2 (October 1951). Statement on the cut-out technique.

13. Luz, Maria. "Témoignages: Henri Matisse." XXe Siècle n.s. (January 1952):55–57. Includes important comments on the cut-outs in relation to Matisse's art as a whole.

14. MacChesney, Clara T. "A Talk with Matisse, Leader of Post-Impressionists." New York Times Magazine 9 (March 1913).

15. Matisse, Henri. "Notes d'un peintre." La Grand Revue LII, 24 (25 December 1908):731–745. The crucial early statement of Matisse's artistic ideals.

16. _____ . "Dva pisma [Two letters to A. Romm]." Iskusstvo 4 (1934):199–203. Supplemented by Matiss. Zivopis, skul'ptura, grafika, pisma. (Leningrad: 1969), pp. 130–133. Letters on the Barnes murals and the issues of architectural painting.

17. _____ . Jazz. Paris: Editions Verve, 1947. There is also a reduced-size facsimile edition, containing fewer than the original number of plates and a foreword by E. Tériade (Munich: Piper, 1957).

18. _____ . "La Chapelle du Rosaire des Dominicaines de

Vence." *France Illustration* 320 (1 December 1951):561–570. Reprinted as "La Chapelle de Vence, aboutissement d'une vie." *XXe Siècle* special number, "Hommage à Henri Matisse," (1970):71–73. Paris, Grand Palais. *Henri Matisse Exposition de Centenaire, 1970.* See bibl. 44.

19. Purrmann, Hans, ed. *Farbe und Gleichnis; Gesammelte Schriften.* Zurich: der Arche, 1955. Includes fourteen of Matisse's writings with a memoir by Purrman.

20. Rouveyre, André. "Matisse évoque." *La Revue des Arts* VI, 2 (June 1956):66–74.

St. Louis Art Museum and Detroit Institute of Arts. *Henri Matisse, Paper Cut-Outs, 1977.* See bibl. 71.

21. Tériade, E. "Visite à Henri Matisse." *L'Intransigeant XXII* (14 January 1929). Parts reprinted as "Propos de Henri Matisse à Tériade," *Verve* IV, 13 (December 1945):56. Retrospective statements by Matisse, preceding his Tahitian voyage.

22. _____ . "Entretien avec Tériade." *L'Intransigeant* (20, 27 October 1930). An important statement on light and space in Tahiti and America.

23. _____ . "Constance du fauvisme." *Minotaure* II, 9 (15 October 1936):3.

24. _____ . "Matisse Speaks." *Art News* L, 8 (November 1951):40–71; *Art News Annual* 21 (1952):40–71. A major autobiographical statement.

25. Verdet, André. *Prestiges de Matisse.* Paris: Editions Emile-Paul, 1952. Contains crucial descriptions of Matisse's working methods and attitudes toward the cut-outs. Also see *XXe Siecle*, special number, 1970. See bibl. 51.

B. Books and Catalogues on Matisse

26. Aragon, Louis. *Henri Matisse, Roman.* Paris: Gallimard, 1971. 2 vol. English translation: *Henri Matisse: a novel.* London: Collins, 1972.

27. *Art in America* 63, 4 (July-August 1975). A special number on Matisse. For selected articles, see bibl. 63, 77.

28. *Arts Magazine* 49, 9 (May 1975). "Special issue: Matisse." For selected articles, see bibl. 53, 56, 62, 75.

29. Baltimore, Museum of Art. *Matisse as a Draughtsman, 1971.* Introduction and catalogue entries by Victor I. Carlson.

30. Barr, Alfred H., Jr. *Matisse: His Art and his Public.* New York: The Museum of Modern Art, 1951. Still the standard work on Matisse although it does not treat his last four years and requires some revision in light of more recent research. Contains numerous important quotations by Matisse as well as the seminal analyses of his works and account of his career.

31. Copenhagen, Statens Museum for Kunst. *Matisse, En retrospektiv udstilling, 1970.*

32. *Critique, revue générale* XXX, 324 (May 1974). A special number, "Henri Matisse," including conversations with Matisse recorded by André Masson and an essay by Dominique Fourcade, "Rêver à trois aubergines," on the patterned works of 1911.

33. Diehl, Gaston, *Henri Matisse.* Paris: Pierre Tisné. 1954.

34. Duthuit, Georges. *Les Fauves.* Geneva: Trois Collines, 1949. English edition: *The Fauvist Painters.* New York: Wittenborn, Schulz, 1950. A study of the seminal Fauve period in Matisse's work and that of his colleagues by Matisse's son-in-law. See also bibl. 35, 43.

35. Elderfield, John. *The "Wild Beasts": Fauvism and its Affinities.* New York: The Museum of Modern Art. 1976.

36. _____ . *Matisse in the Collection of The Museum of Modern Art.* New York: The Museum of Modern Art, 1978. Commentaries on the paintings, sculptures, and cut-outs in this major Matisse collection with additional entries on the prints and drawings by Riva Castleman and William S. Lieberman respectively.

37. Elsen, Albert E. *The Sculpture of Henri Matisse.* New York: Abrams, 1972. The standard work on Matisse's sculpture, with important observations on its relationship to other branches of his art, including the cut-outs. Usefully supplemented by bibl. 54, 65.

38. Escholier, Raymond. *Matisse, ce vivant.* Paris: A. Fayard, 1956. English edition: *Matisse from the Life.* London: Faber & Faber, 1960.

39. Jacobus, John. *Henri Matisse.* New York: Abrams, 1972. Focused on Matisse and the interior, particularly the studio interior, as a key to the idea of a harmonious environment. See the review by Lawrence Gowing in bibl. 27, p. 17.

40. Lieberman, William S. *Matisse. Fifty Years of His Graphic Art.* New York: George Braziller, 1956.

41. London, The Arts Council of Great Britain. *Matisse, 1869–1954.* With an important introductory essay by Lawrence Gowing, an earlier version of which appeared in the catalogue *Henri Matisse: 64 Paintings.* New York: The Museum of Modern Art, 1966.

42. Los Angeles, University of California. *Henri Matisse, 1966.* With texts by Jean Leymarie, Herbert Read, and William S. Lieberman.

43. Oppler, Ellen Charlotte. "Fauvism Reexamined." Ph.D. dissertation, Columbia University, New York 1969.

44. Paris, Grand Palais. *Henri Matisse Exposition du Centenaire, 1970.* Introduction by Pierre Schneider. An important catalogue with all datings provided by the Matisse family and containing quotations from unpublished Matisse letters.

45. Paris, Musée National d'Art Moderne. *Le Fauvisme français et les debuts de l'Expressionisme allemand, 1968.* Catalogue by Michel Hoog and Leopold Reidmeister.

46. Paris, Musée National d'Art Moderne. *Henri Matisse: Dessins et Sculpture, 1975.* Introduction by Dominique Fourcade.

47. Pleynet, Marcelin. *L'Enseignement de la peinture.* Paris: Editions du Seuil, 1971. Includes the useful essay, "Le Système de Matisse."

48. Russell, John. *The World of Matisse, 1869–1954.* New York: Time Life Books, 1969.

49. San Lazzaro, G. di, ed. *Homage to Henri Matisse.* New York: Tudor, 1970. Essays by Georges Rouault, Jean Casson, Roger Fry, Jean Leymarie, Herbert Read, et al.

50. Trapp, Frank Anderson. "The Paintings of Henri Matisse: Origins and Early Development (1890–1917)." Ph.D. dissertation, Harvard University, 1951.

51. *XXe Siècle*, special number, "Hommage à Henri Matisse" (1970). Includes statements by Matisse on a wide range of topics, and twelve essay-memoirs. See also bibl. 18.

52. *Yale Literary Magazine* special number, "Homage to Matisse" 123 (Autum 1955).

C. Articles on Matisse

53. Ashton, Dore. "Matisse and Symbolism." *Arts Magazine* 49, 9 (May 1975):70–71.

54. Elderfield, John. "Matisse Drawings and Sculpture." *Artforum* XI, 1 (September 1972):77–85.

55. Flam, Jack D. "Matisse in 1911: At the Crossroads of Modern Painting." In *Actes du 22e Congrès International d'Histoire de l'Art, Budapest 1969*, II, pp. 421–430. Budapest: Akademiai Kaidó, 1972.

56. _____ . "Some Observations on Matisse's Self-Portraits." *Arts Magazine* 49, 9 (May 1975):50–52.

57. Greenberg, Clement. "Influences of Matisse." In *Henri Matisse.* New York: Acquavella Galleries, Inc., 1973.

58. Kramer, Hilton. "Matisse as a Sculptor." *Bulletin, Museum of Fine Arts, Boston* LXIV (1966):49–65.

59. Livingston; Jane. "Matisse's 'Tea'." *Los Angeles County Museum of Art Bulletin* XX, 2 (1974):47–57.

60. Marmer, Nancy. "Matisse and the Strategy of Decoration." *Artforum* IV (March 1966):28–33.

61. Moffett, Kenworth. "Matisse in Paris." *Artforum* IX (October 1970):69–71.

62. Neff, John Hallmark. "Matisse and Decoration: an Introduction." *Arts Magazine* 49 (May 1975):59–61; (June 1975):85.

63. _____ . "Matisse and Decoration: The Shchukin Panels." *Art in America* 63, 4 (July-August 1975):38–48.

64. Schapiro, Meyer. "Matisse and Impressionism." *Androcles* I, 1 (February 1932):21–36.

65. Tucker, William. "Four Sculptors, Part 3: Matisse." *Studio International* 180, 925 (September 1970):82–87.

D. *Books and Catalogues on the Cut-Outs*

66. Bern, Kunsthalle. *Henri Matisse, 1950 – 1954: Les Grandes Gouaches Découpées*, 1959. Essay by Franz Meyer. Catalogue of the first major exhibition of the large cut-outs.

Matisse, Henri. *Jazz*, 1947. See bibl. 17.

67. New York, The Museum of Modern Art. *The Last Works of Henri Matisse: Large Cut Gouaches*, 1961. Introduction by Monroe Wheeler. The first important American exhibition of the cut-outs.

68. Paris, Musée National d'Art Moderne. *Henri Matisse: Oeuvres Récentes, 1947–1948*, 1949. The first showing of the cut-outs in France. The catalogue includes unsigned notes by Matisse.

69. Paris, Berggruen et Cie. *Henri Matisse Papiers Découpés*, 1953. The first exhibition showing only cut-outs. Catalogue introduction by E. Tériade.

70. Paris, Musée des Arts Décoratifs. *Henri Matisse: Les Grandes Gouaches Découpées*, 1961. An important exhibition of large-scale cut-outs. Catalogue text by Jacques Lassaigne.

71. St. Louis, The St. Louis Art Museum, and Detroit, The Detroit Institute of Arts. *Henri Matisse. Paper Cut-Outs*, 1977. A seminal exhibition and catalogue. Contains Introduction by Jack Cowart; "Matisse, His Cut-Outs and the Ultimate Method" by John Hallmark Neff; "Jazz" by Jack D. Flam; "Something Else" by Dominique Fourcade; plus fully illustrated and annotated catalogue of four-fifths of the extant cut-outs, Technical Appendix by Antoinette King, an appendix of documents on the cut-outs, and a list of exhibitions and bibliography.

72. Stockholm, National Museum. *Henri Matisse: Apollon*, 1957. Catalogue essay by Bo Wennberg.

73. *Verve* 35–36. Special issue: "Last works by Matisse 1950–1954," 1958. Includes "Le tailleur de lumière" by Georges Duthuit and "Matisse dans la lumière est le bonheur" by Pierre Reverdy. Also an English-language edition: New York, 1958.

E. *Articles on the Cut-Outs*

74. Courthion, Pierre. "Le Papier Collé du Cubisme à nos jours" and "Les Papiers Découpés d'Henri Matisse." *XXe Siècle* n.s., 6 (January 1956):3–60.

75. Cowart, Jack. "Matisse's Artistic Probe: The Collage." *Arts Magazine* 49, 9 (May 1975):53–55. Principally a study of *Beasts of the Sea* (1950) and associated works.

76. Elderfield, John. "Henri Matisse. *Blue Nude I*. 1952." In *European Master Paintings from Swiss Collections. Post-Impressionism to World War II*, p. 76. New York: The Museum of Modern Art, 1976.

77. Goldin, Amy. "Matisse and Decoration: The Late Cut-Outs." *Art in America* 63, 4 (July-August 1975):49–59.

78. Leymarie, Jean. "Les grandes gouaches découpées à la Kunsthalle de Bern." *Quadrum* 7 (1959):103–114. (English summary p. 192.)

79. Marchiori, Giuseppe. "Papiers Découpés." *La Biennale de Venezia* 26 (1955):28–20.·

80. Millard, Charles W. "Matisse in Paris." *The Hudson Review* 23, 3 (Autumn 1970):540–545.

81. Murphy, Richard W. "Matisse's Final Flowering." *Horizon* XII, 1 (1970):26–41.

LIST OF COLOR PLATES

All works illustrated are paper cut-outs, with the exception of Pls. 2, 3, 4, and 5, which are stencil prints, and Pls. 6 and 7, which are silk-screen prints; all six are after paper cut-out maquettes. In all cases the dates given are of the execution of the original cut-outs.

1 *Two Dancers, "Rouge et Noir"*
1937 – 38
31¹¹/₁₆″ x 25⅜″
Private Collection.

2 *The Toboggan, Jazz, Plate 20*
Early 1943
12¾″ x 11⅜″ (approx.)
Tériade (Paris: 1947)
Collection, The Museum of Modern Art, New York. Gift of the artist.

3 *Icarus, Jazz, Plate 8*
1943
16⅝″ x 10⅝″
Tériade (Paris: 1947)
Collection, The Museum of Modern Art, New York. Gift of the artist.

4 *The Codomas, Jazz, Plate 11*
Early 1944
16⅝″ x 25⅝″ (approx.)
Tériade (Paris: 1947)
Collection, The Museum of Modern Art, New York. Gift of the artist.

5 *The Knife Thrower, Jazz, Plate 15*
1943 – early 1944
16⅝″ x 25¾″ (approx.)
Tériade (Paris: 1947)
Collection, The Museum of Modern Art, New York. Gift of the artist.

6 *Oceania, The Sky*
Summer 1946
64^{15}/$_{16}$" x 149^5⁄$_8$" (approx.)
Musée National d'Art Moderne. (Photo: Cliches Musée Nationaux Paris)

7 *Oceania, The Sea*
Summer 1946
65" x 149^5⁄$_8$" (approx.)
Musée National d'Art Moderne. (Photo: Cliches Musée Nationaux Paris).

8 *Polynesia, The Sky*
1946
78¾" x 123^5⁄$_8$"
Mobilier National, Paris, on loan to Centre National d'Art et Culture Georges Pompidou, Musée National d'Art Moderne, Paris.

9 *Polynesia, The Sea*
1946
77^3/$_{16}$" x 123^5⁄$_8$" (approx.)
Mobilier National, Paris, on loan to Centre National d'Art et Culture Georges Pompidou, Musée National d'art Moderne, Paris.

10 *Four Petaled Flower*
1945 – 46
24^7/$_{16}$" x 15^{13}/$_{16}$"
Private collection.

11 *Amphitrite*
1947
33^5⁄$_8$" x 27^5⁄$_8$"
Private collection, France.

12 *Composition with Red Cross*
1947
28^1⁄$_8$" x 20^5⁄$_8$"
Mrs. Maruja Baldwin Hodges, Newport Beach.

13 *The Bird and The Shark*
1947
16" x 41½"
Mr. and Mrs. Morton Neumann, Chicago.

14 *Composition (The Velvets)*
1947
20¼" x 85^5⁄$_8$"
Kunstmuseum, Basel. (Photo: Hans Hinz)

15 *The Panel with Mask*
1947
43^5/$_{16}$" x 20^7⁄$_8$"
Det Danske Kunstindustrimuseum, Copenhagen. (Photo: Ole Woldbye)

16 *Composition, Violet and Blue*
1947
15^{15}/$_{16}$" x 20½"
Det Danske Kunstindustrimuseum, Copenhagen. (Photo: Ole Woldbye)

17 *Composition, Black and Red*
1947
15^{15}/$_{16}$" x 20^7⁄$_8$"
Wellesley College, Wellesley.

18 *The Bees*
Summer 1948
39¾" x 94^7⁄$_8$" (approx.)
Musée Matisse, Nice. (Photo: M. Berard)

19 *Zulma*
Early 1950
93¾" x 52^3⁄$_8$"
Statens Museum for Kunst, Copenhagen. (Photo: Hans Petersen)

20 *The Thousand and One Nights*
June 1950
54¾" x 147¼"
Museum of Art, Carnegie Institute, Pittsburgh, Pennsylvania.

21 *The Tree of Life: Nave*
1949
202¾" x 202¾"
The Vatican Museums, Collection of Modern Religious Art.

22 *The Tree of Life: Apse*
1949
202¾" x 99^1⁄$_8$"
The Vatican Museums, Collection of Modern Religious Art

23 *Creole Dancer*
June 1950
80¾" x 47¼"
Musée Matisse, Nice. (Photo: M. Berard)

24 *The Beasts of the Sea*
1950
116^1⁄$_8$" x 60^5⁄$_8$"
National Gallery of Art, Washington, D.C. Ailsa Mellon Bruce Fund.

25 *Snow Flowers*
1951
68^3/$_{16}$" x 31^7⁄$_8$"
Mr. and Mrs. Jacques Gelman Collection, Mexico City.

26 *Chinese Fish*
1951
75^{11}/$_{16}$" x 35^7⁄$_8$"
Vicci Sperry, Los Angeles.

27 *The Swimming Pool*
1952
90½″ x 647⅝″
Collection, The Museum of Modern Art, New York.

28 *The Wine Press*
c. 1951
68⅞″ x 32¼″
Maurice Lefebvre-Foinet, Paris.

29 *Mimosa*
1949–51
58¼″ x 38″
Museum of Twentieth Century Art, Itoh City.

30 *Maquette for Nuit de Noël*
1952
123⅛″ x 53½″
Collection, Museum of Modern Art, New York. Gift of Time Inc.

31 *Sorrow of the King*
1952
115″ x 155⅞″
Centre National d'Art et Culture Georges Pompidou, Musée National d'Art Moderne, Paris.

32 *Blue Nude I*
1952
45¹¹/₁₆″ x 30¾″
Ernst Beyeler, Basel.

33 *Blue Nude II*
1952
45¾″ x 35″
Private Collection.

34 *The Parakeet and the Mermaid*
1952
132¹¹/₁₆″ x 304⅜″
Stedelijk Museum, Amsterdam.

35 *Blue Nude IV*
1952
40½″ x 30½″
Private Collection, France.

36 *Acrobats*
1952
83¹³/₁₆″ x 82½″
Private Collection.

37 *Venus*
1952
39⅞″ x 30⅛″
National Gallery of Art, Washington, D.C. Ailsa Mellon Bruce Fund.

38 *The Snail*
1952–53
112⅝″ x 113″
The Tate Gallery, London.

39 *Memory of Oceania*
1952–53
112″ x 112″
Collection, The Museum of Modern Art, New York. Mrs. Simon Guggenheim Fund.

40 *The Negress*
1952–53
178¾″ x 245½″
The National Gallery of Art, Washington, D.C. Ailsa Mellon Bruce Fund.

41 *Large Decoration with Masks*
1953
139¼″ x 392½″
National Gallery of Art, Washington, D.C. Ailsa Mellon Bruce Fund.

42 *Women and Monkeys*
1952
28¼″ x 112¹¹/₁₆″
Galerie Beyeler, Basel.

43 *The Wild Poppies*
31½″ x 134⅝″
Detroit Institute of Fine Arts, Detroit

44 *Ivy in Flower*
1953
111⅞″ x 112⅝″
Dallas Museum of Fine Arts, Dallas, Foundation for the Arts Collection. Gift of the Albert and Mary Lasker Foundation. (Photo: Bill S. Strehorn, Dallas)

45 *The Acanthi*
1953
122⁷/₁₆″ x 138″
Ernst Beyeler, Basel, on long-term loan to Basel Kunstmuseum.
© S.P.A.D.E.M., 1978

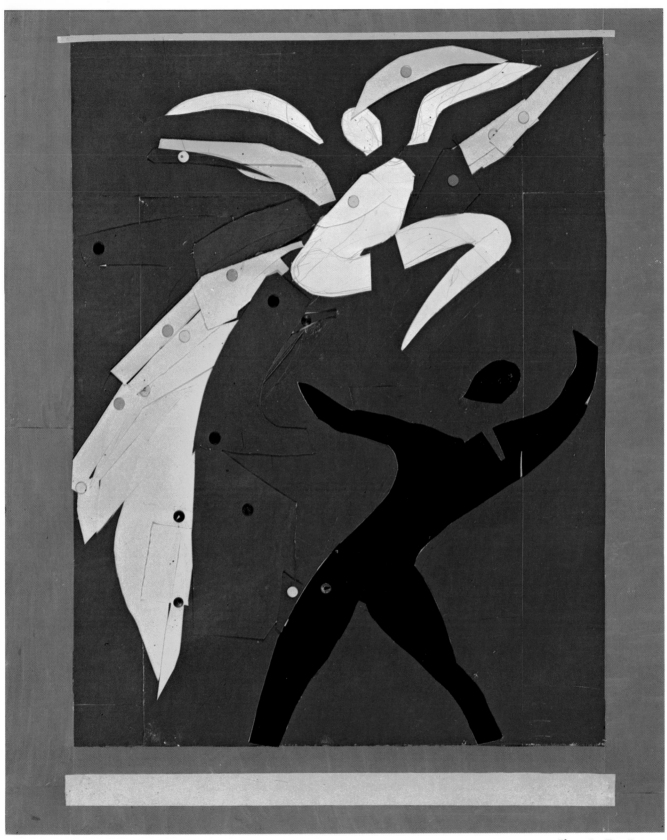

Plate 1 Two Dancers

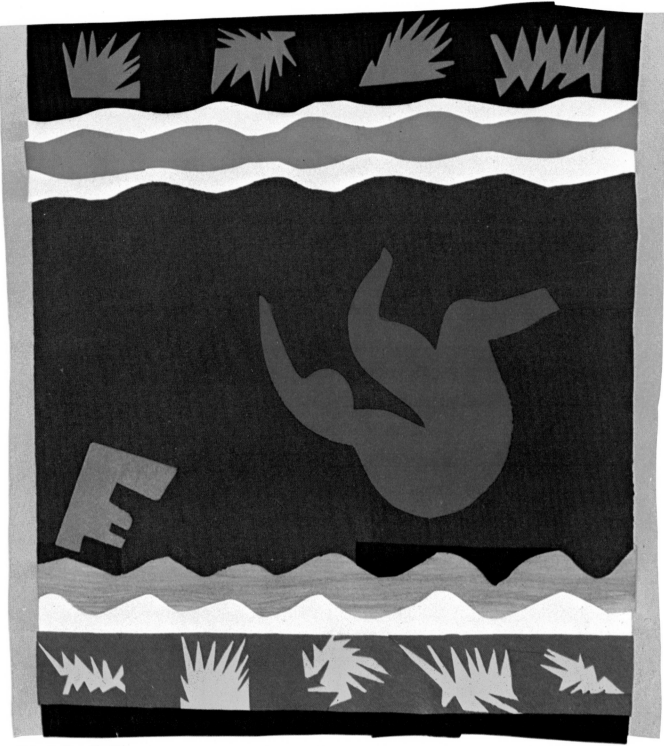

Plate 2 Jazz: The Toboggan

50

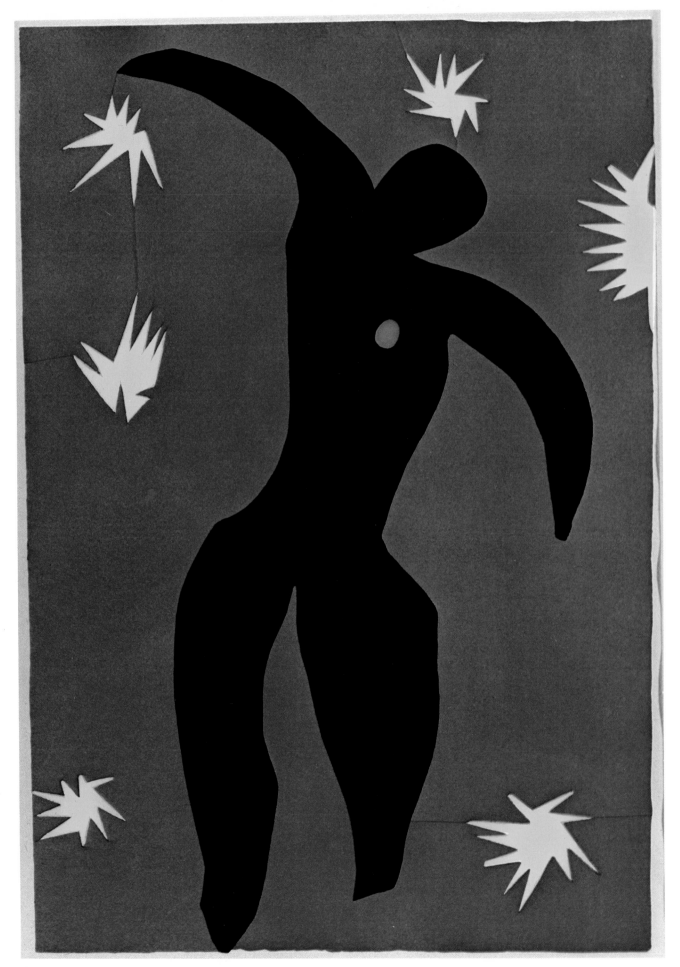

Plate 3 Jazz: Icarus

Plate 4 Jazz: The Codomas

Plate 5 Jazz: The Knife Thrower

Plate 6 Oceania, the Sky

Plate 7 Oceania, the Sea

Plate 8 Polynesia, the Sky

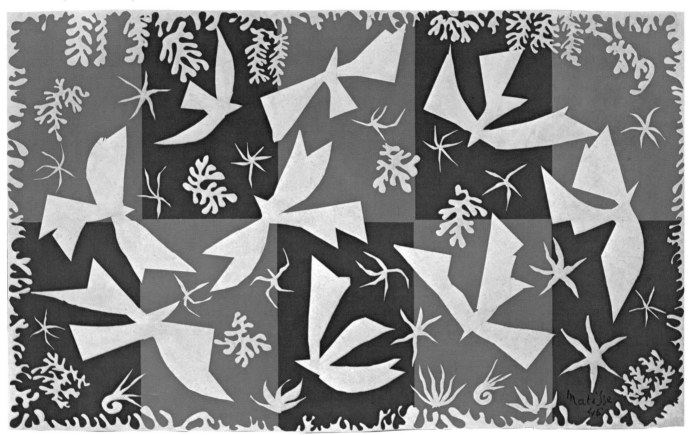

Plate 9 Polynesia, the Sea

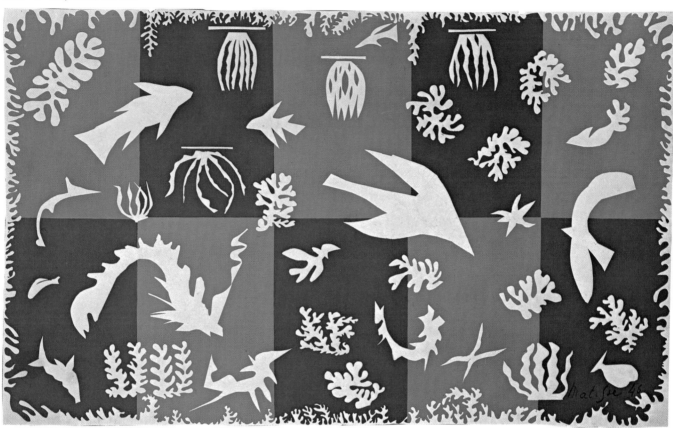

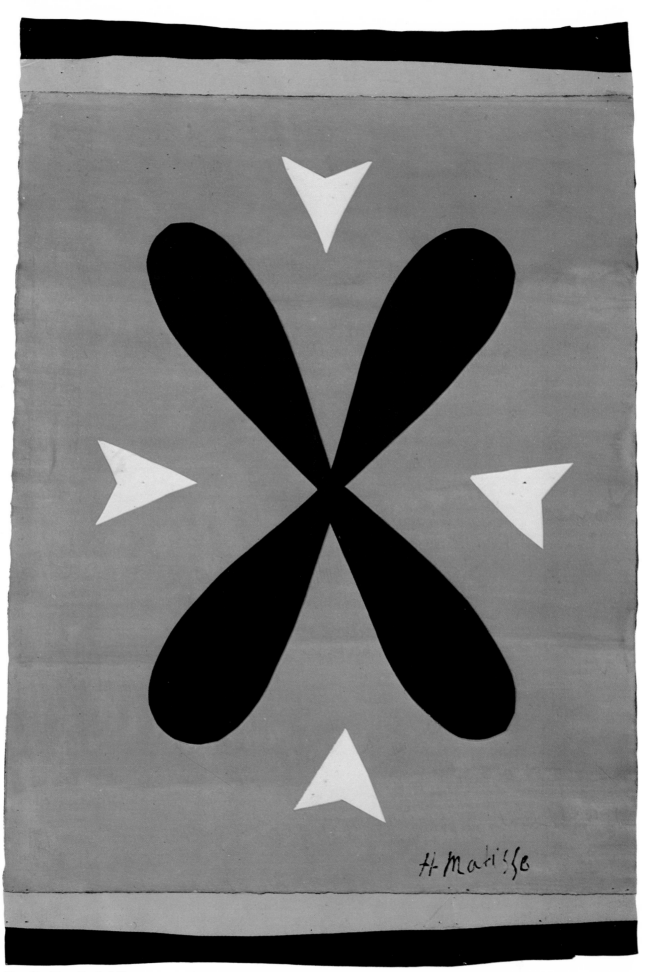

Plate 10 Four Petaled Flower

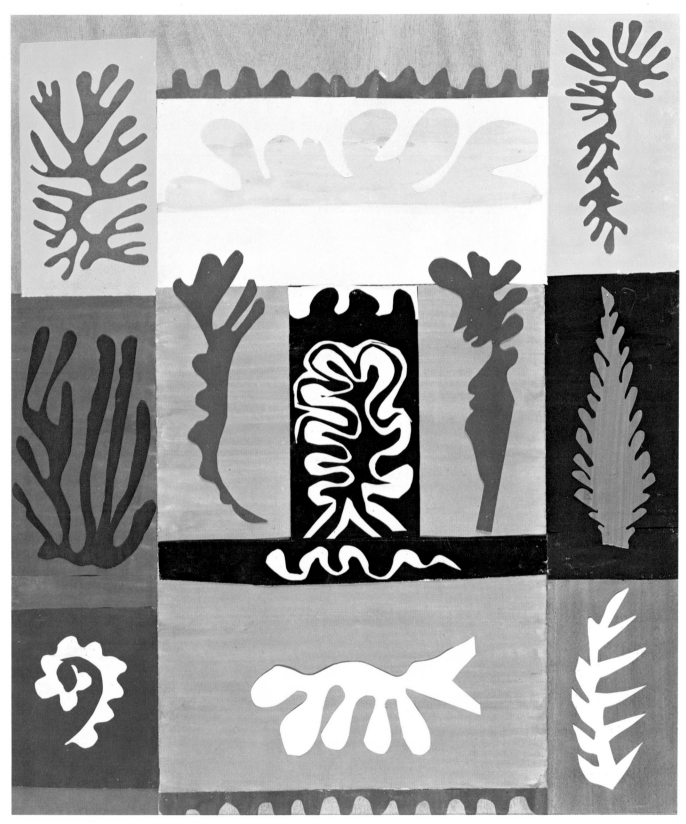

Plate 11 Amphitrite

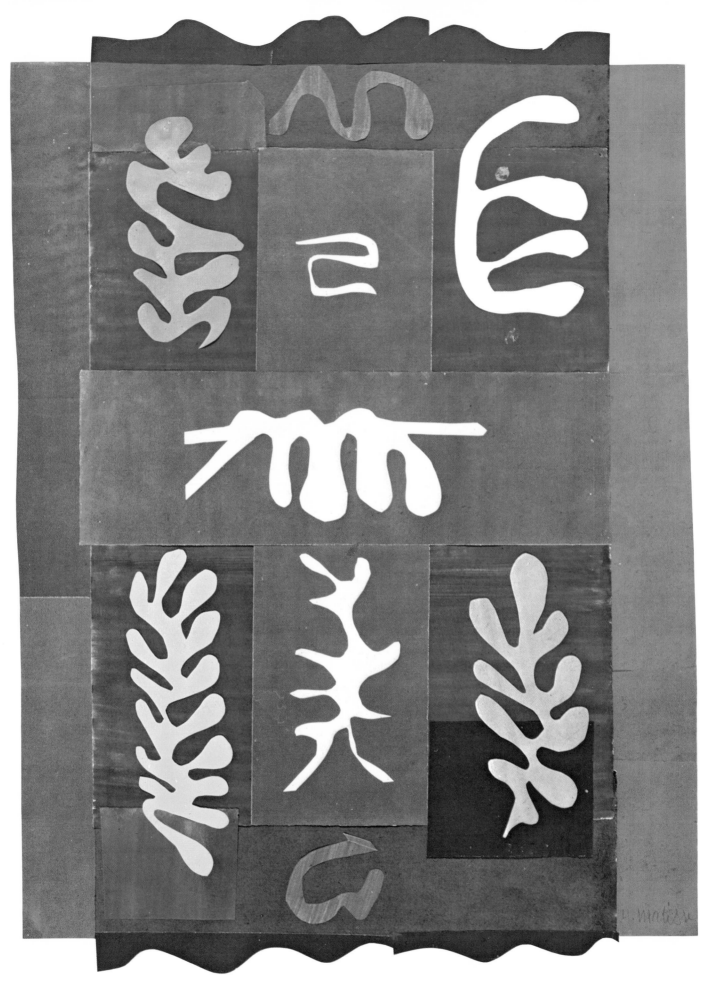

Plate 12 Composition with Red Cross

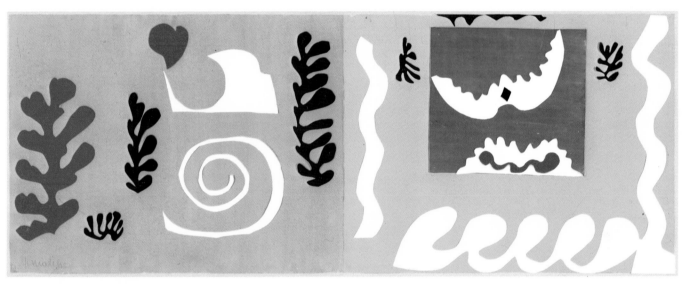

Plate 13 The Bird and the Shark

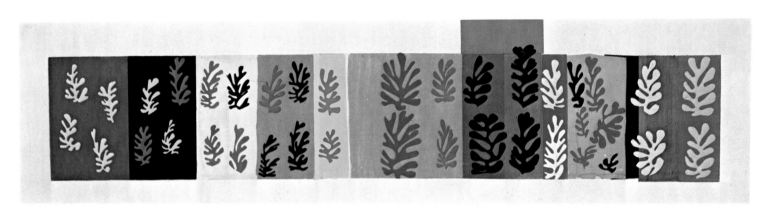

Plate 14 Composition (The Velvets)

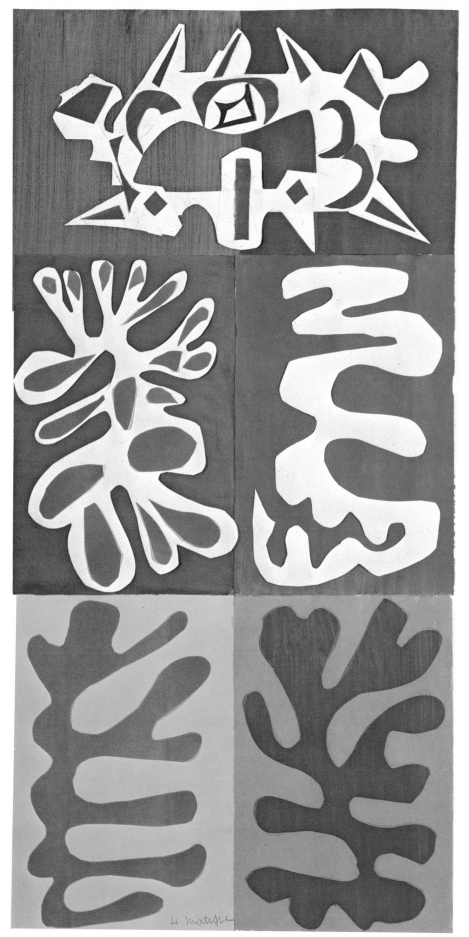

63

Plate 15 The Panel with Mask

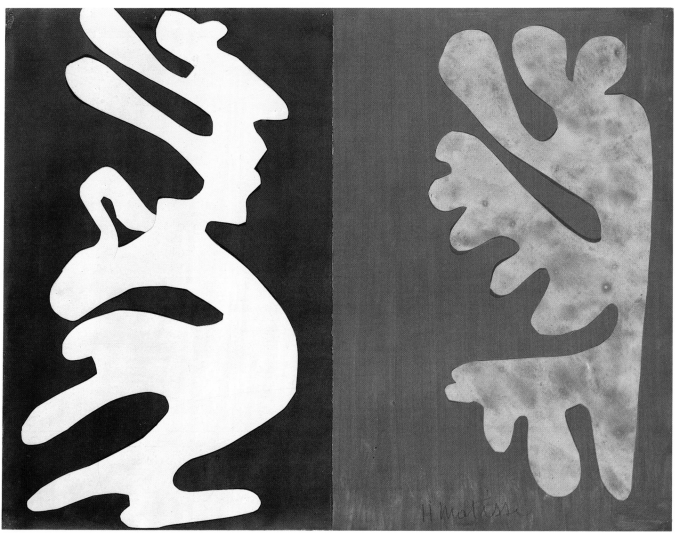

Plate 16 Composition, Violet and Blue

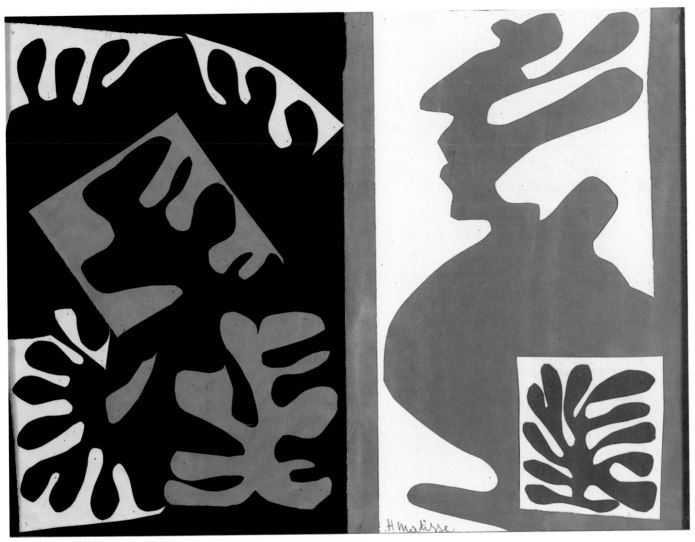

Plate 17 Composition, Black and Red

Plate 18 The Bees

66

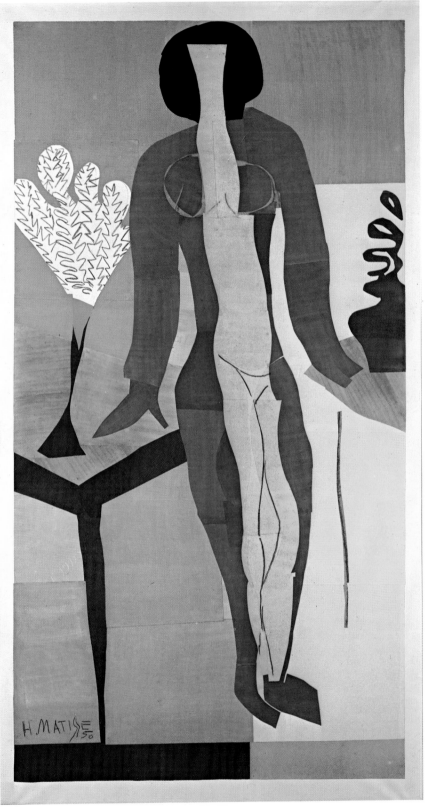

Plate 19 Zulma

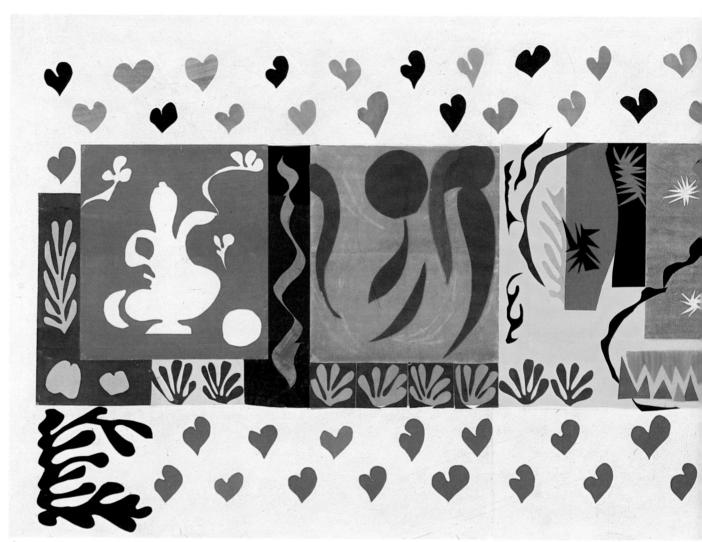

Plate 20 The Thousand and One Nights

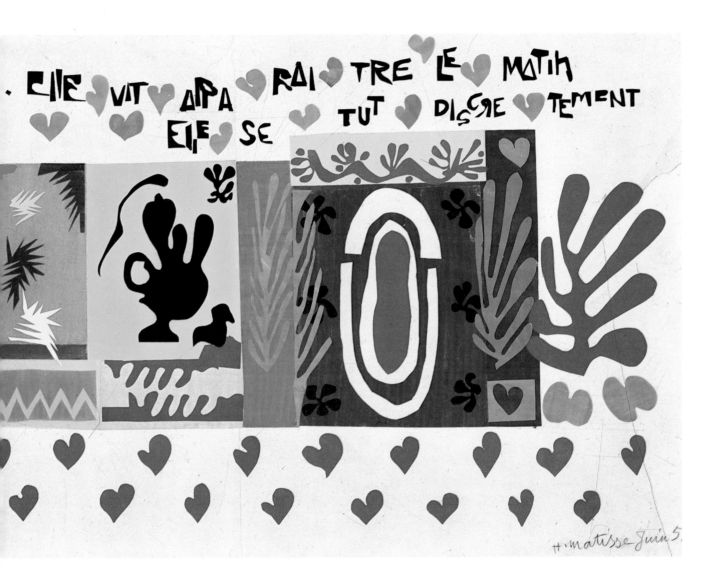

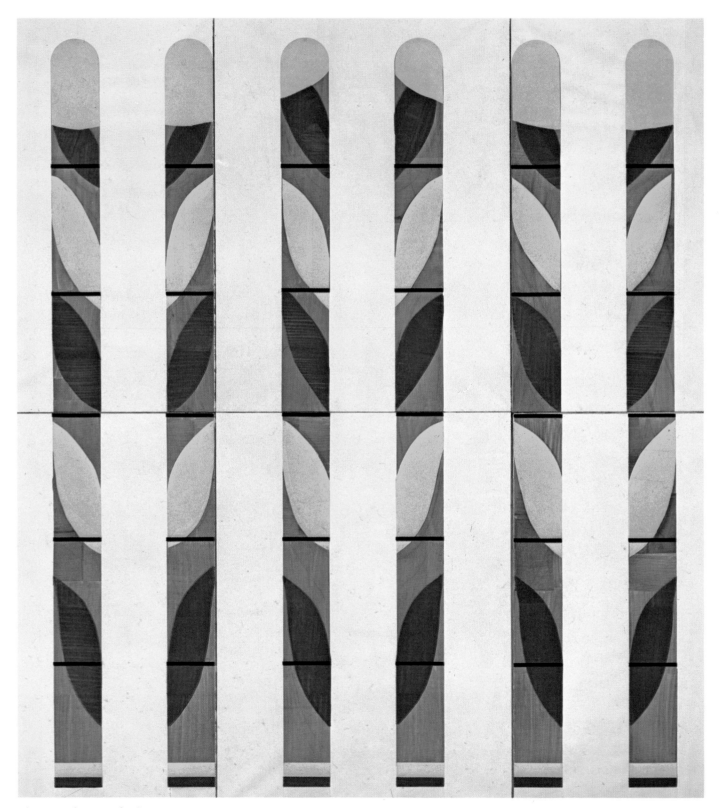

Plate 21 The Tree of Life: Nave

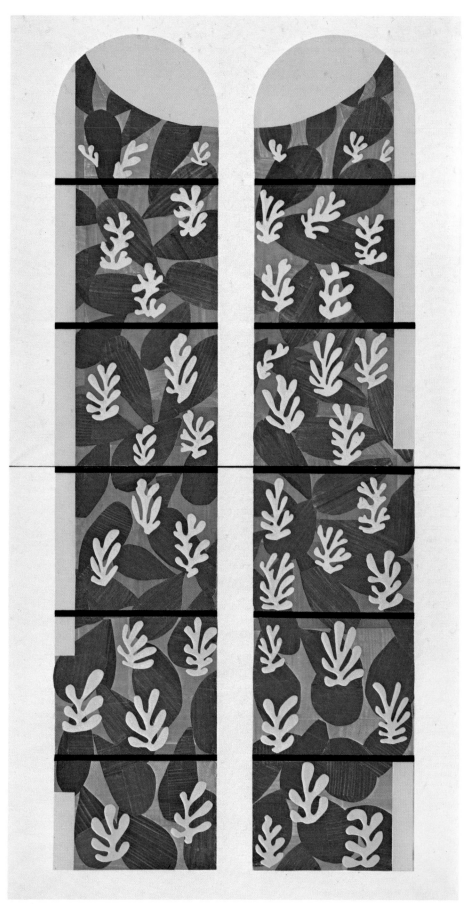

Plate 22 · The Tree of Life: Apse

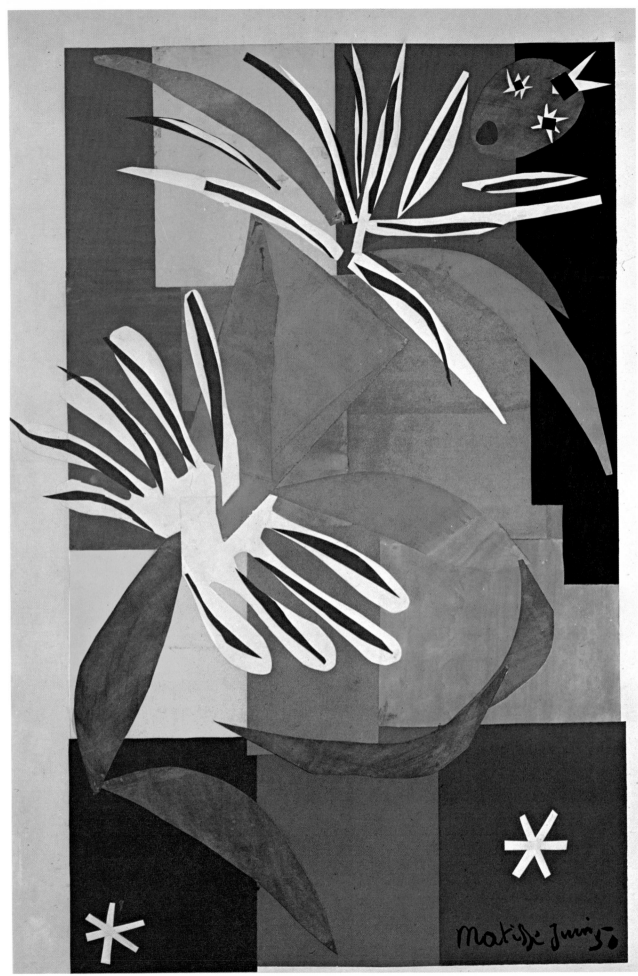

Plate 23 Creole Dancer

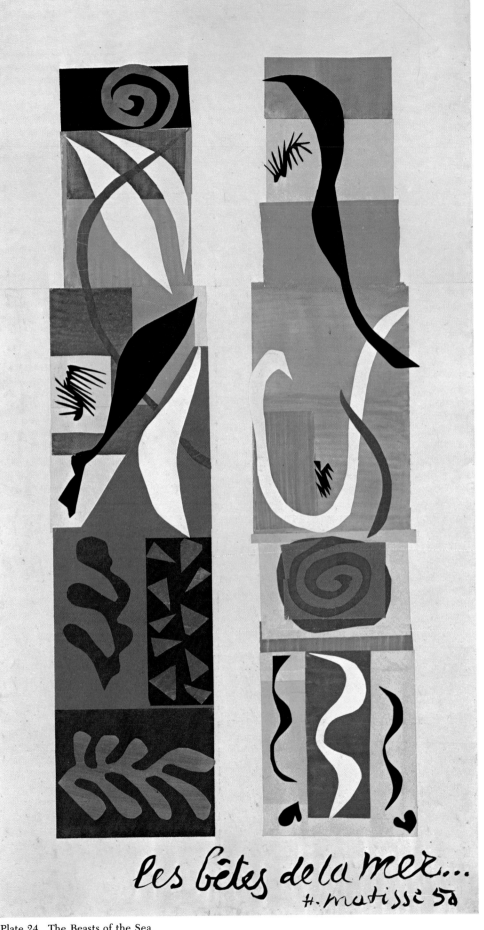

Plate 24 The Beasts of the Sea

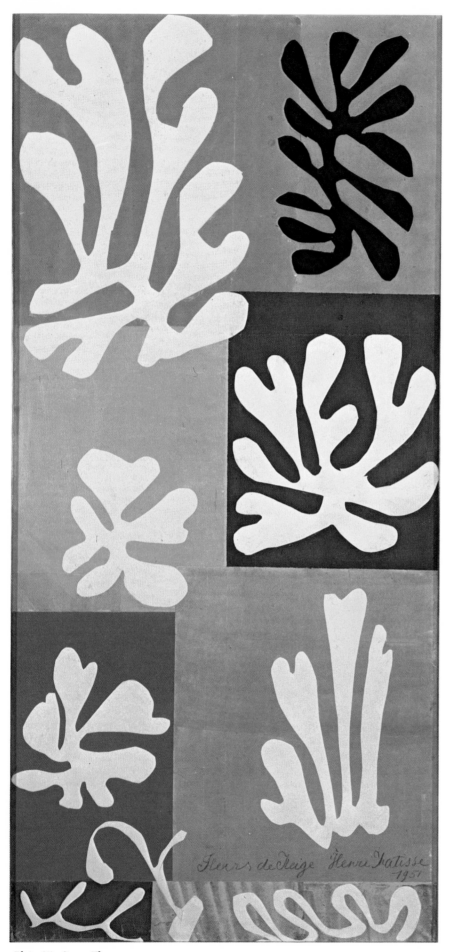

Plate 25 Snow Flowers

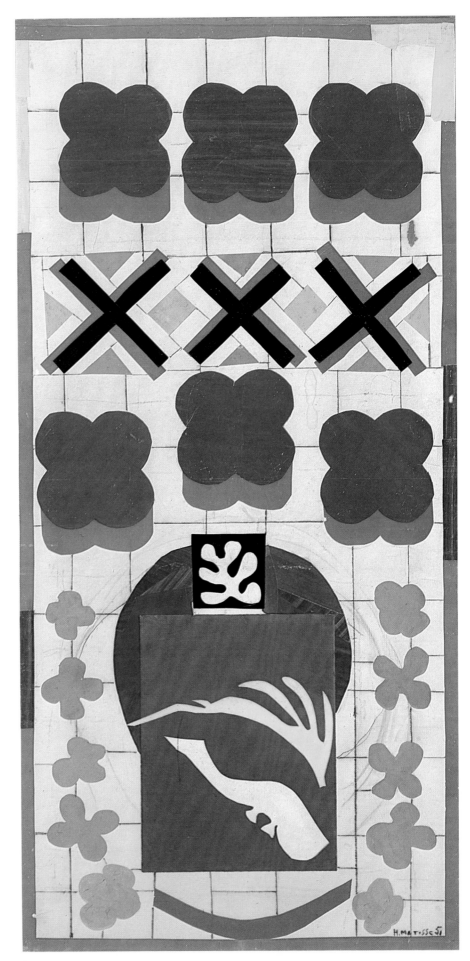

Plate 26 Chinese Fish

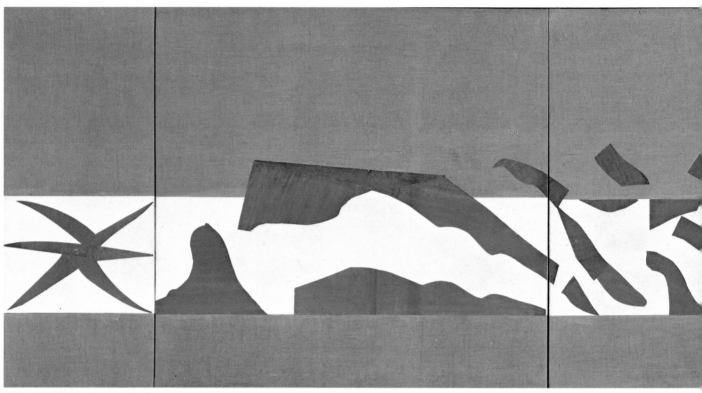

Plate 27 The Swimming Pool

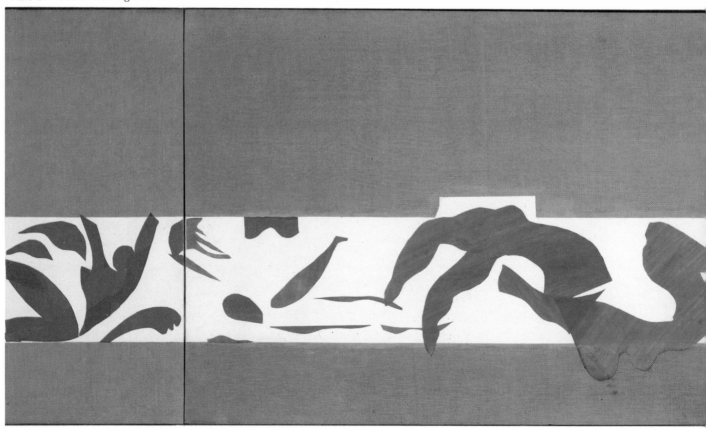

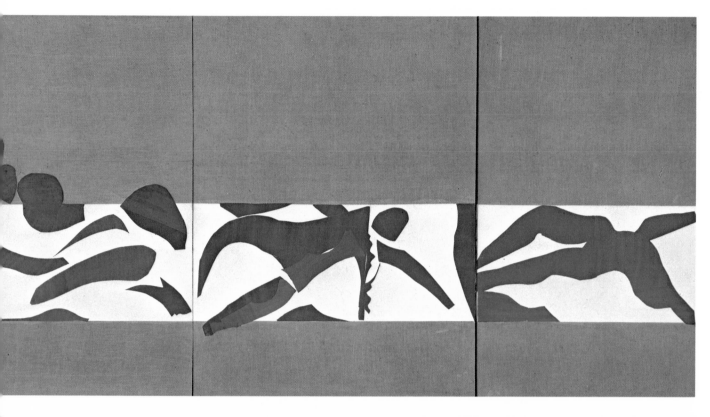

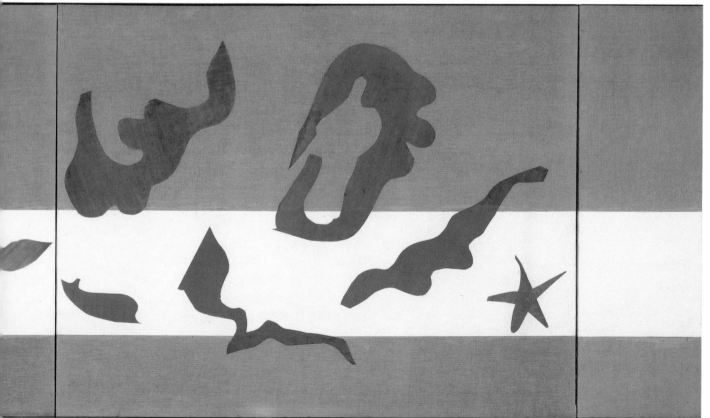

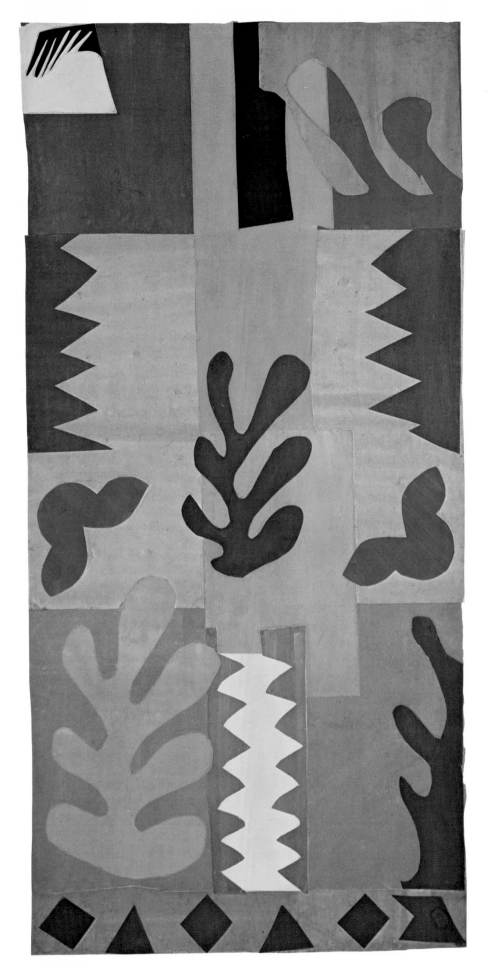

Plate 28 The Wine Press

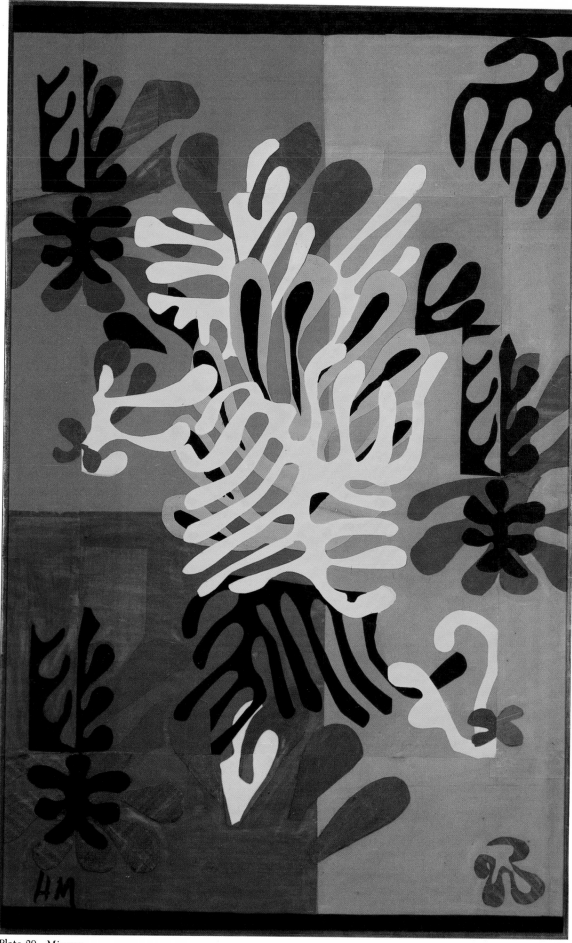

Plate 29 Mimosa

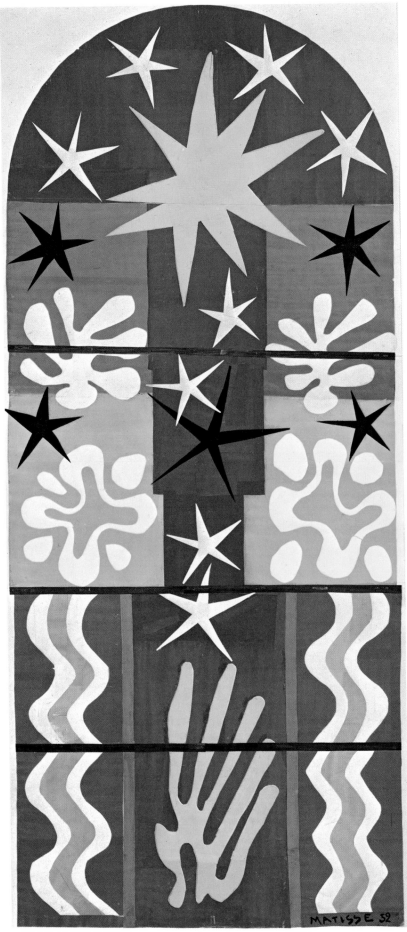

Plate 30 Nuit de Noël

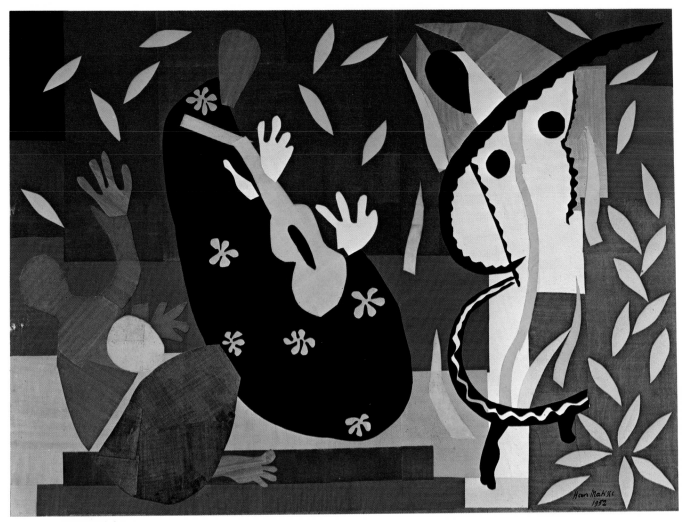

Plate 31 Sorrow of the King

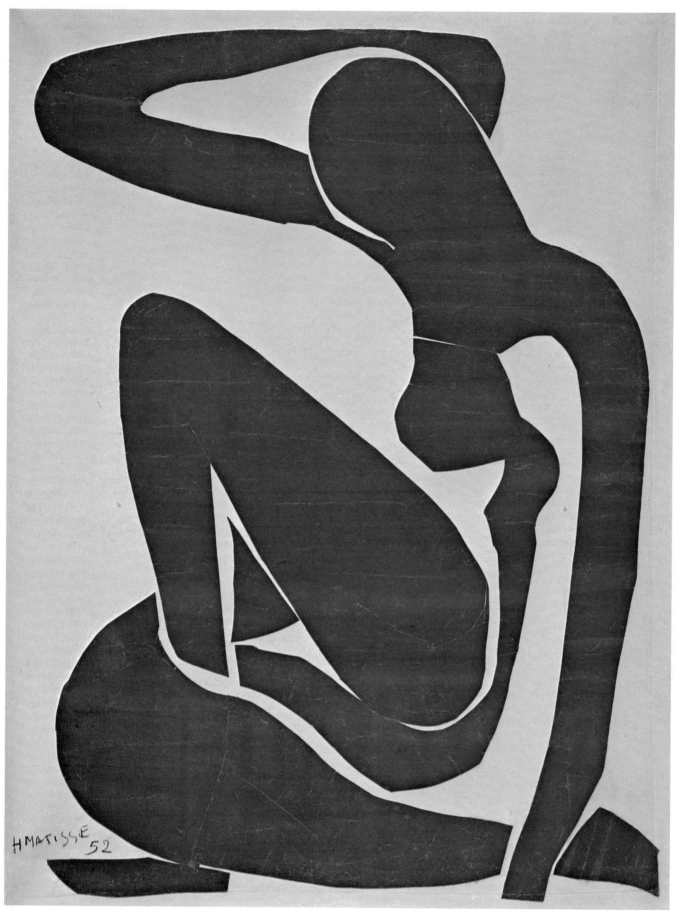

Plate 32 Blue Nude I

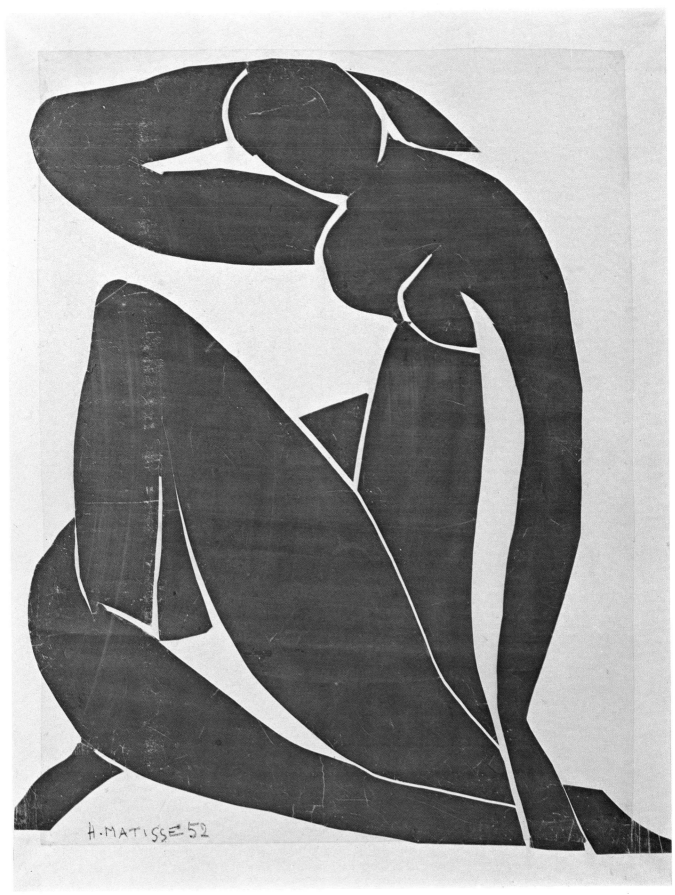

Plate 33 Blue Nude II

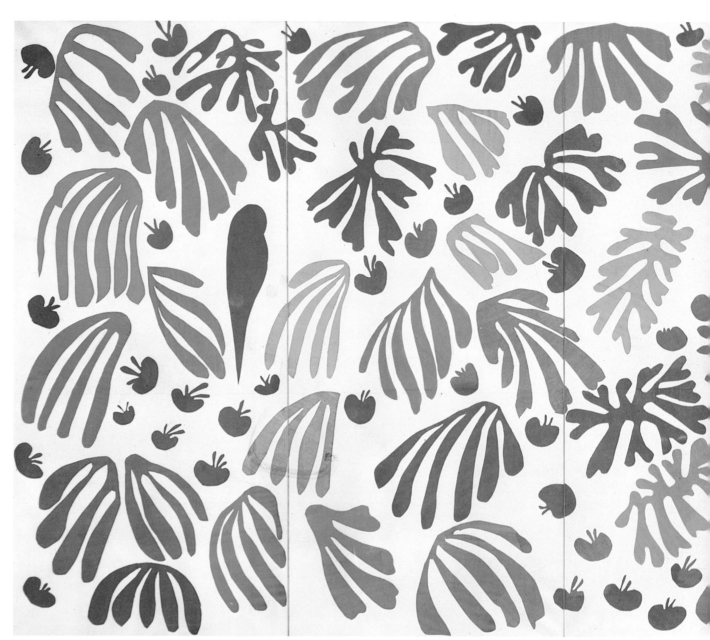

Plate 34 The Parakeet and the Mermaid

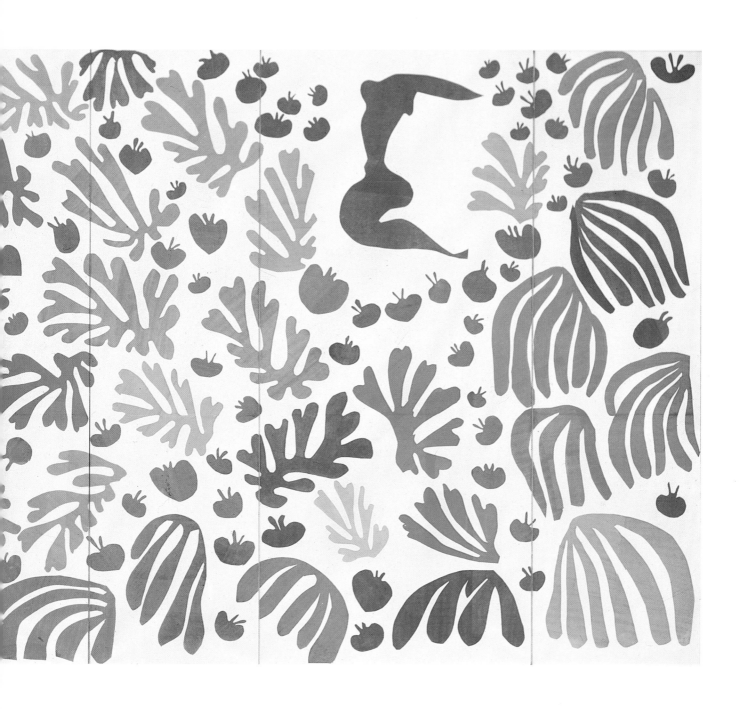

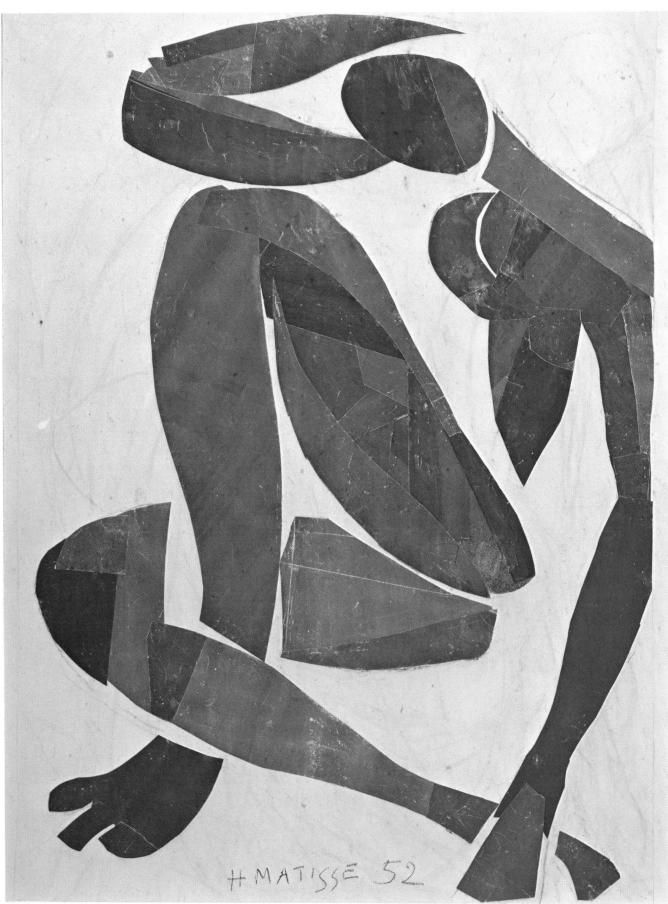

Plate 35 Blue Nude IV

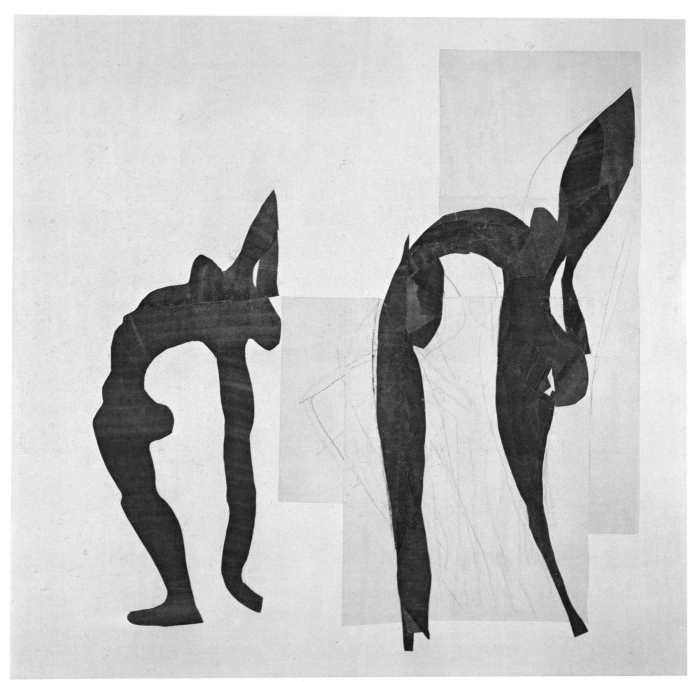

Plate 36 Acrobats

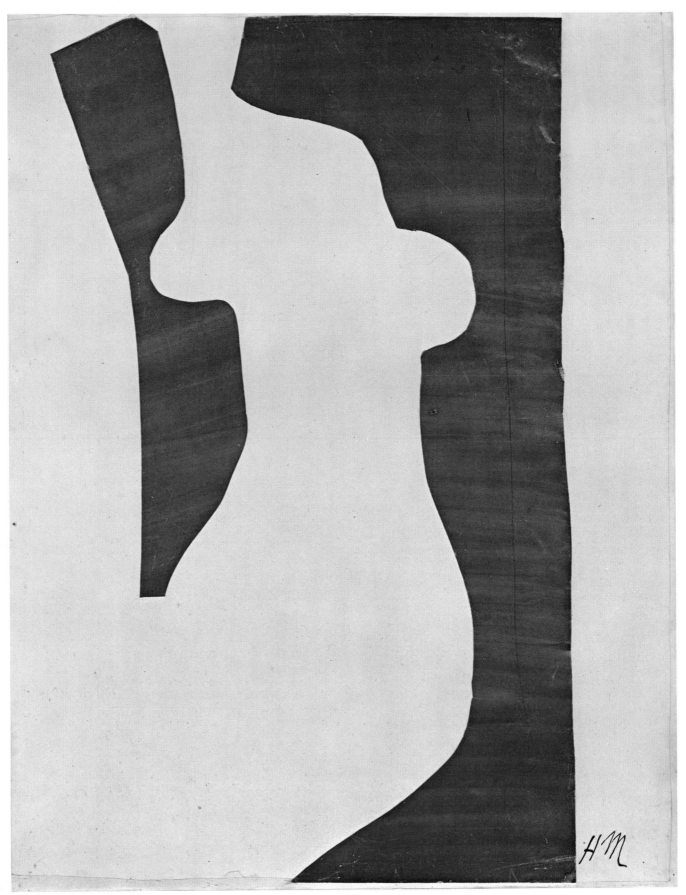

Plate 37 Venus

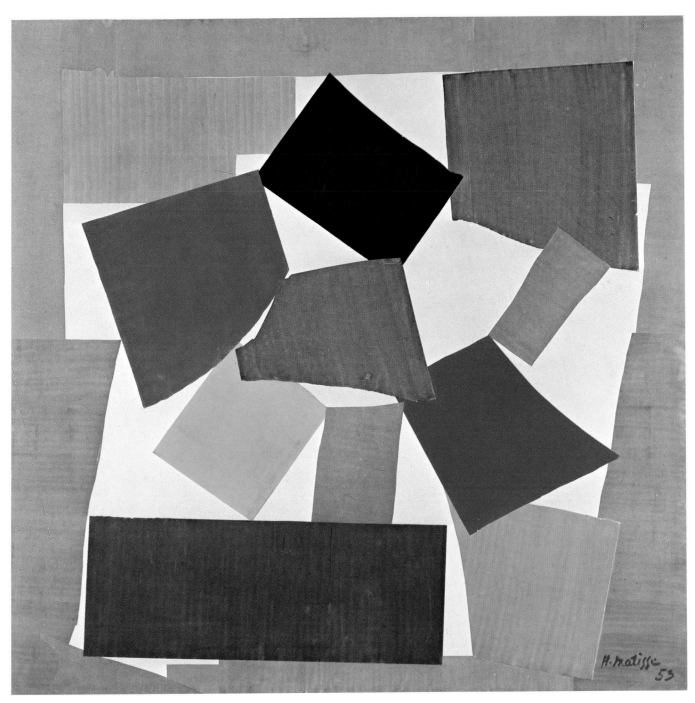

Plate 38 The Snail

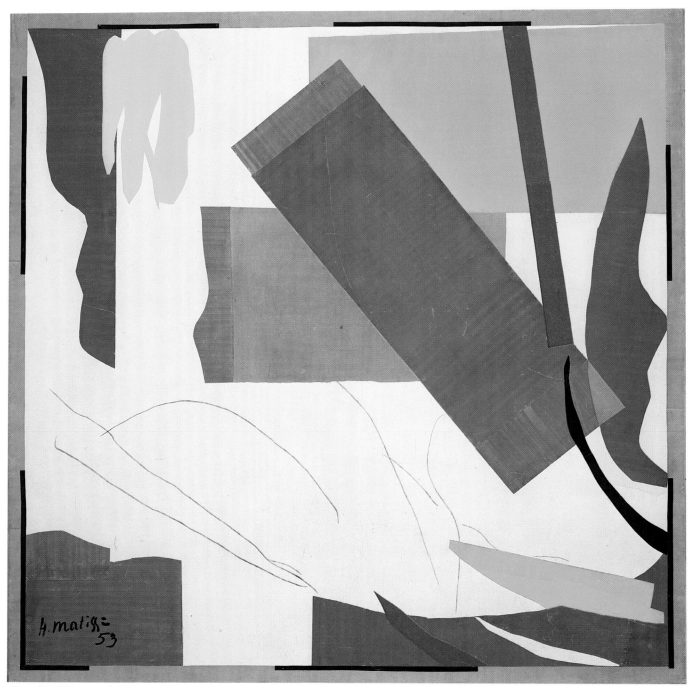

Plate 39 Memory of Oceania

Plate 40 The Negress

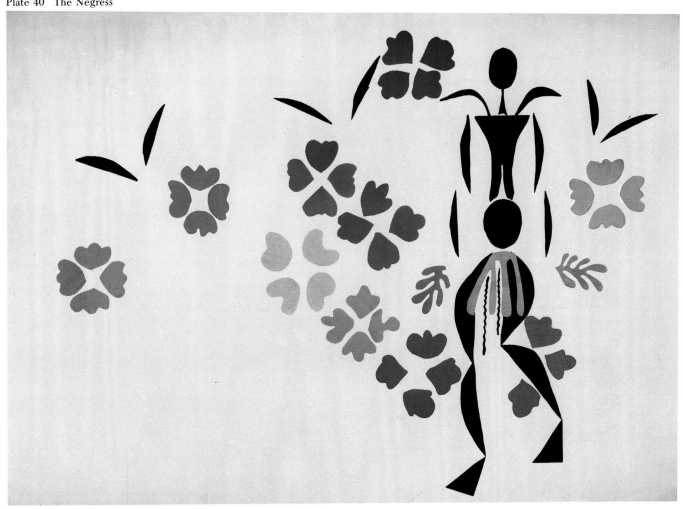

Plate 41 Large Decoration with Masks

Plate 42 Women and Monkeys

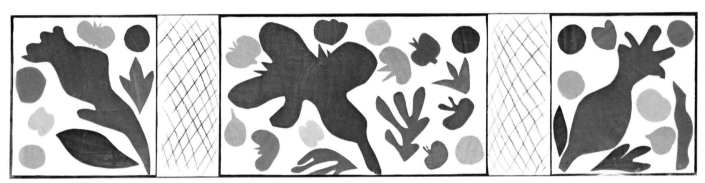

Plate 43 The Wild Poppies

94

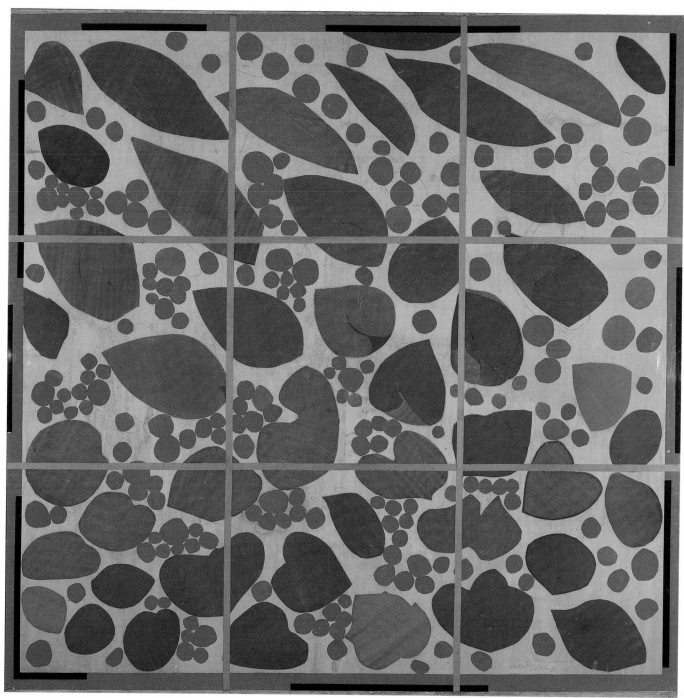

Plate 44 Ivy in Flower

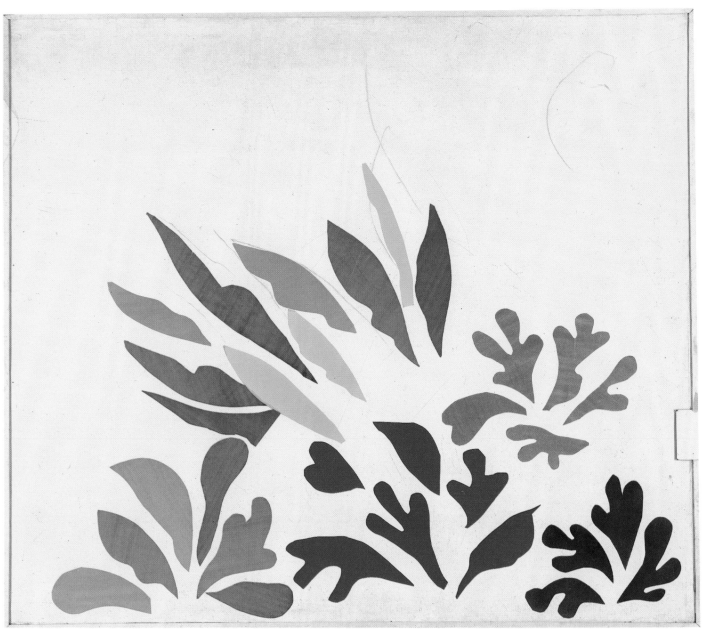

Plate 45 The Acanthi

96

In Matisse's Studios

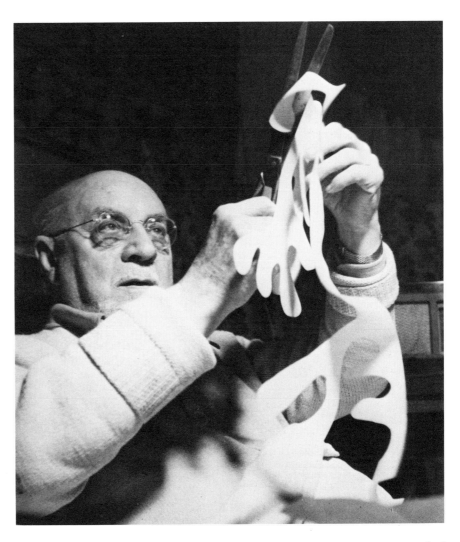

The documentary photographs on the following pages show how Matisse surrounded himself with in-progress and completed cut-outs in his various work rooms, particularly those in his apartment at the Hôtel Régina, Nice.

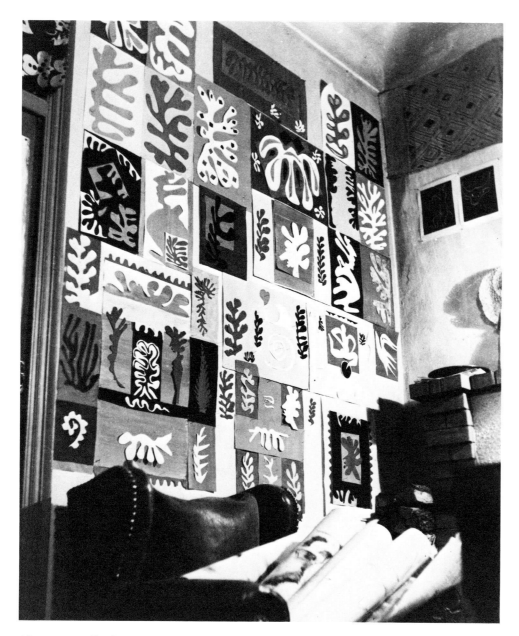

Above: A wall of cut-outs at Matisse's villa, Le Rêve, in Vence around 1947. Among the works shown, some still in progress, are: (left, bottom to top) *Amphitrite* (Pl. 11), *Composition, Black and Red* (Pl. 17), *The Panel with Mask* (Pl. 15); (center bottom) *Composition with Red Cross* (Pl. 12); (below that) *The Bird and the Shark* (Pl. 13); (right center) *Composition, Violet and Blue* (Pl. 16). Right: Matisse at Vence around 1944–45. On the wall in the photograph at the top: the *Forms* plates from *Jazz* below a cut-out composition that is now lost. The large abstract cut-out above the mirror in the other photograph is also lost. Above Matisse's head: the 1940 painting, *Le Rêve*.

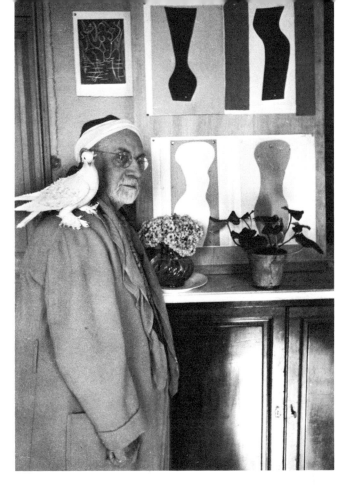

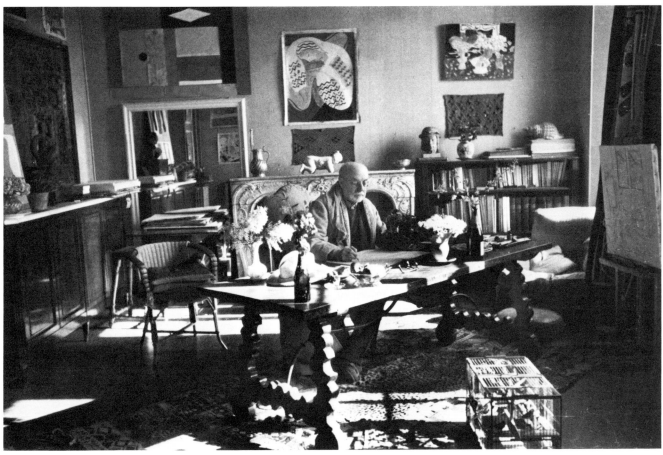

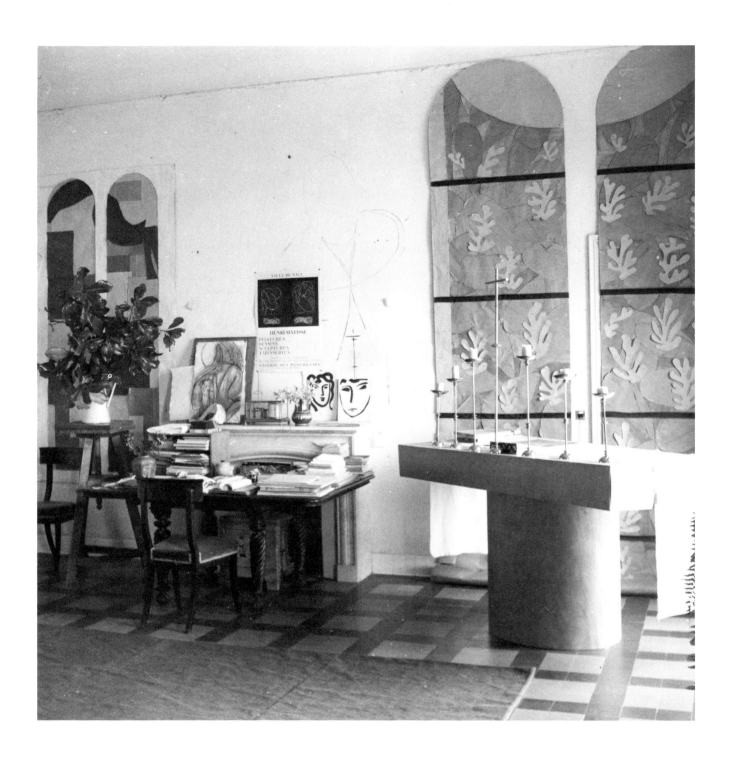

Left: Matisse's studio at Nice around 1951. On the wall to the left, *Jérusalem Céleste*, and to the right, *The Tree of Life* apse window design for the Vence Chapel (Pl. 22), behind a model of the chapel altar. Below: *The Tree of Life* apse window as realized at Vence, the altar, and the ceramic tile Saint Dominic, whose original was sketched on Matisse's bedroom wall.

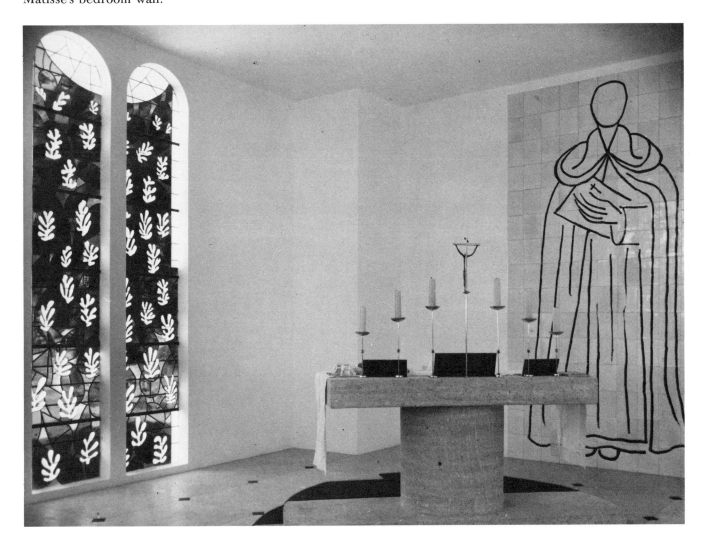

Below: Matisse's Nice studio with *The Tree of Life* choir window designs for the Vence chapel, a preliminary drawing for the nave mural *Ave,* and a model of the chapel.
Right: The nave and choir *The Tree of Life* windows at Vence with part of *The Stations of the Cross* mural visible to the left.

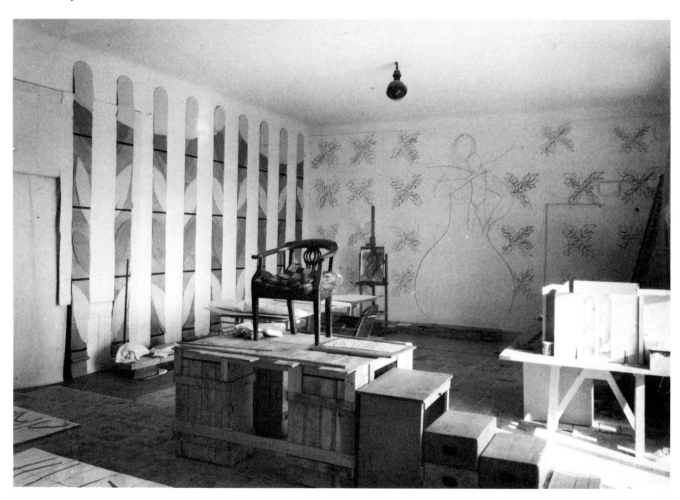

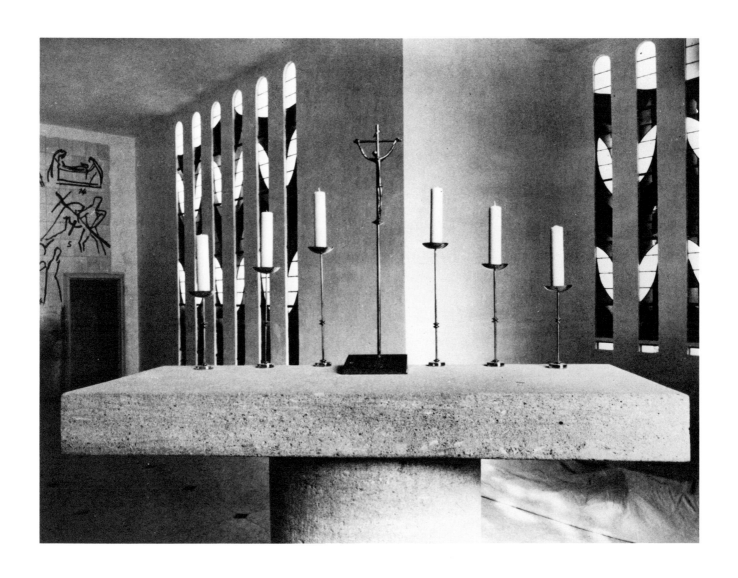

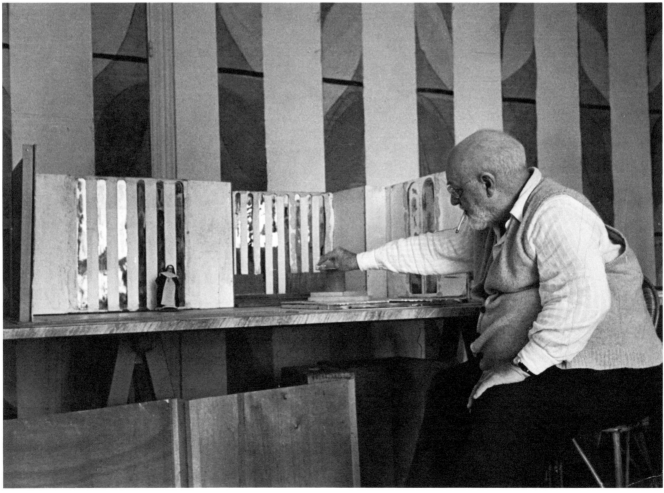

Left, below: Matisse in 1949 with a model of the Vence Chapel interior and *The Tree of Life* window designs in the background. Left top: A model showing the exterior of the chapel. Below: Matisse in the partly finished chapel between the *Stations of the Cross* mural and *The Tree of Life* nave window.

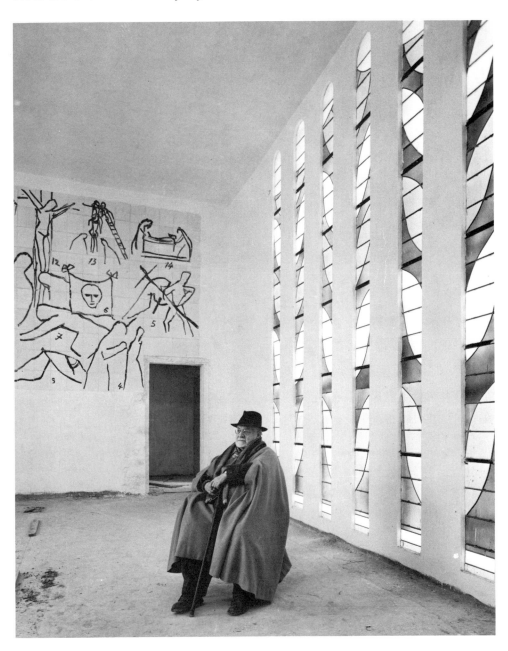

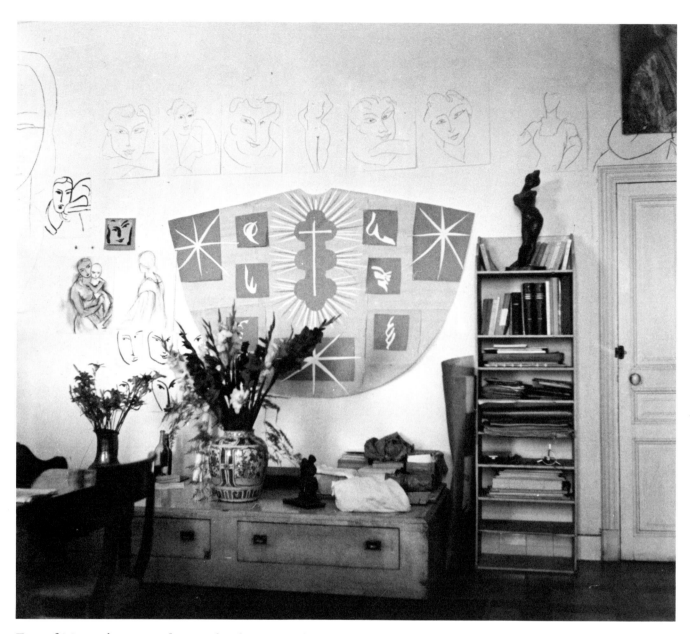

Five of Matisse's cut-out designs for the Vence chasubles in his bedroom at Nice around 1951. Above: back of *Rose Chasuble*. Right (clockwise from lower left): front of *Rose Chasuble, Black Chasuble: "Esperlucat"* (preliminary design), *Rose Chasuble* (preliminary design), *Black Chasuble* (preliminary design). On the mantle piece is Picasso's *Winter Landscape* (1950). On the floor, Matisse's *Katia in a Yellow Dress* (1951). Above the door, Matisse's *The Blue Gandoura* (1951; his last painting), obscuring a Saint Dominic study (see p. 101). The pair of cut-out fish on the door to the right relates to *Chinese Fish* (Pl. 26)

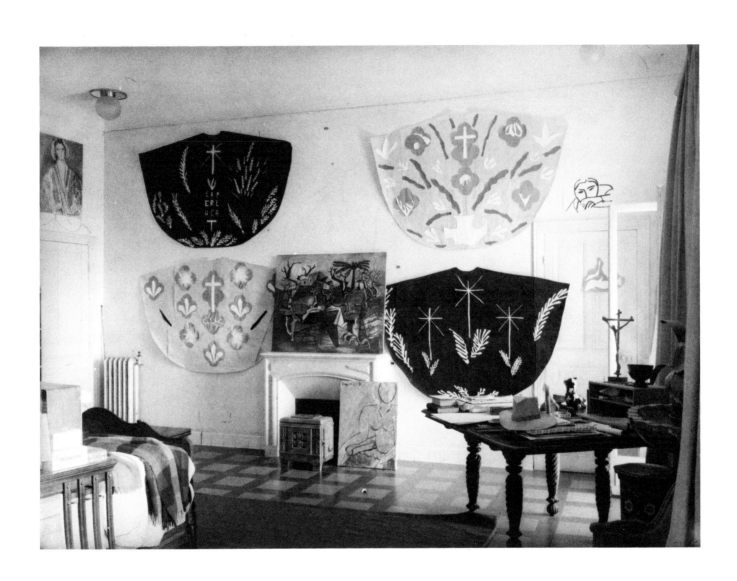

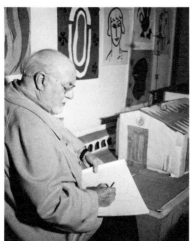

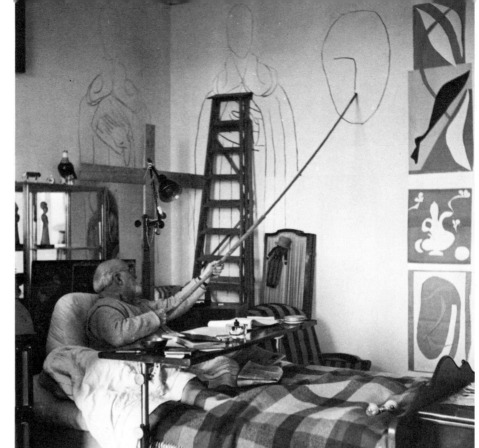

Above left: Matisse drawing from a model of the Vence chapel in his bedroom at Nice in 1950. On the wall, panels of what will become *The Thousand and One Nights* (Pl. 20), and immediately above the model, a single panel cut-out, *Negro Mask*. Above, right: Matisse in the bedroom of his Nice apartment, April 15, 1950. On the walls: panels of what will become *The Thousand and One Nights* (Pl. 20) and *The Beasts of the Sea* (Pl. 24), and the early state of a single panel cut-out, *The Japanese Mask*, immediately above the bed. The head that Matisse is drawing can be seen on page 109 and a 1952 view of the same corner of the room on page 112. Right: In-progress photographs which document the development of *Nuit de Noël* (Pl. 30): top left, January 17, 1952; top right, January 30, 1952; bottom left, early February 1952; bottom right, (completed state), February 27, 1952.

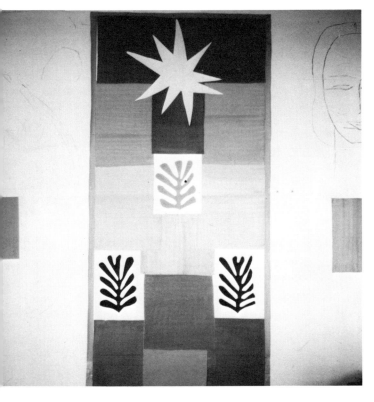

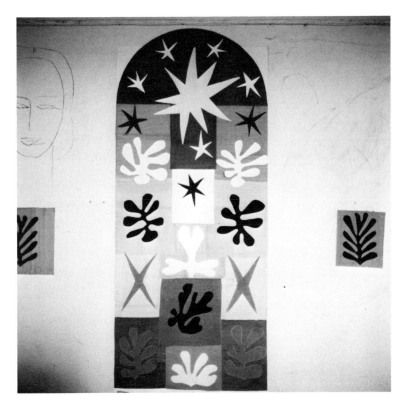

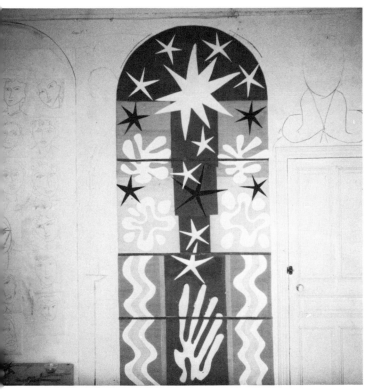

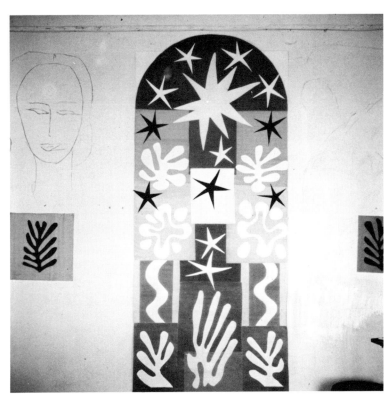

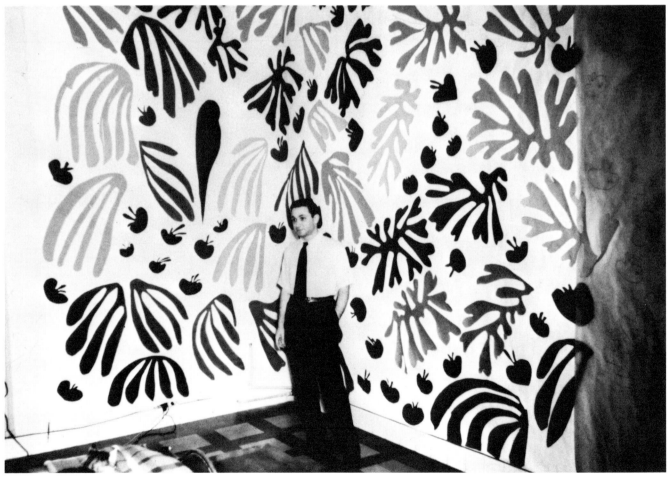

110

Left, top: Matisse sits in front of the completed *The Parakeet and the Mermaid* (Pl. 34) in his bedroom at Nice in 1953. Left, below: John Rewald before the work-in-progress on June 17, 1952. Below: Matisse and an assistant photographed working on the cut-out in 1952.

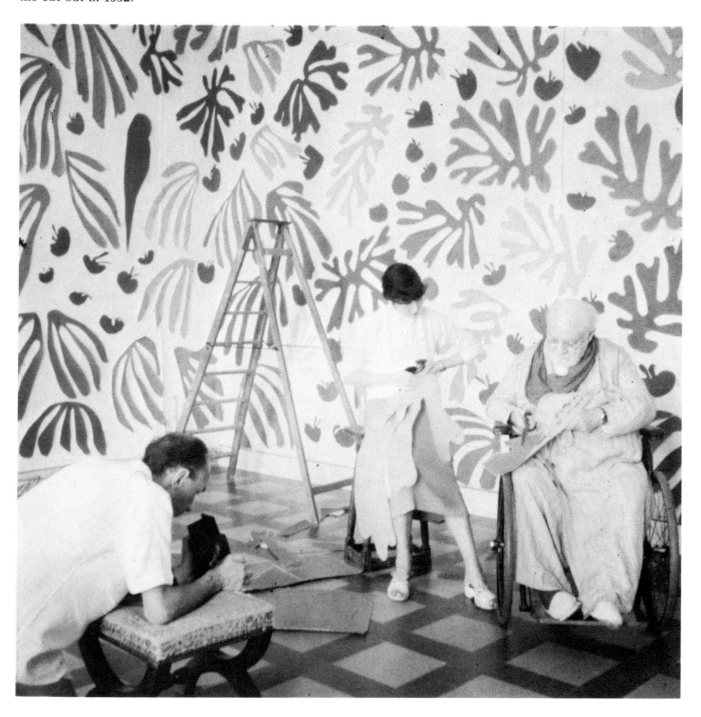

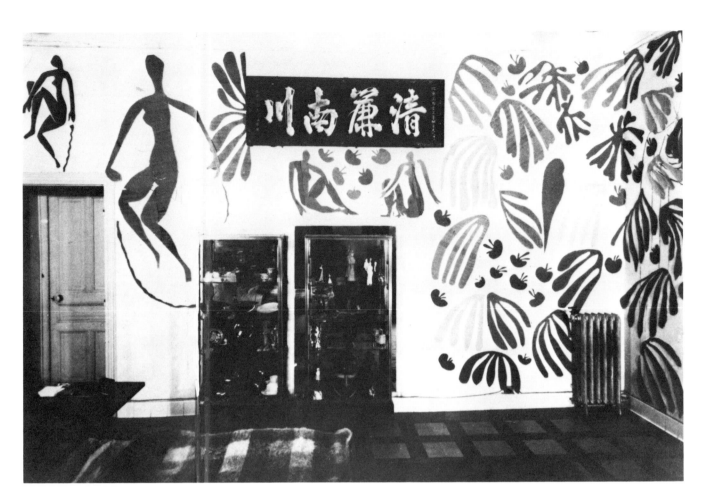

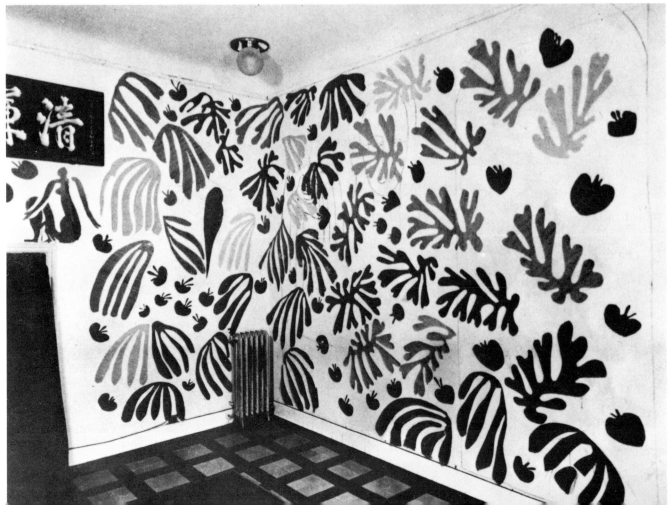

The Parakeet and the Mermaid (Pl. 34) in progress with the completed *Nuit de Noël* cut-out (Pl. 30) at its right; at its left: an early state of the women of *Women and Monkeys* (Pl. 42), *Blue Nude with Green Stockings,* and (above the door) *Blue Nude, Jumping Rope.*

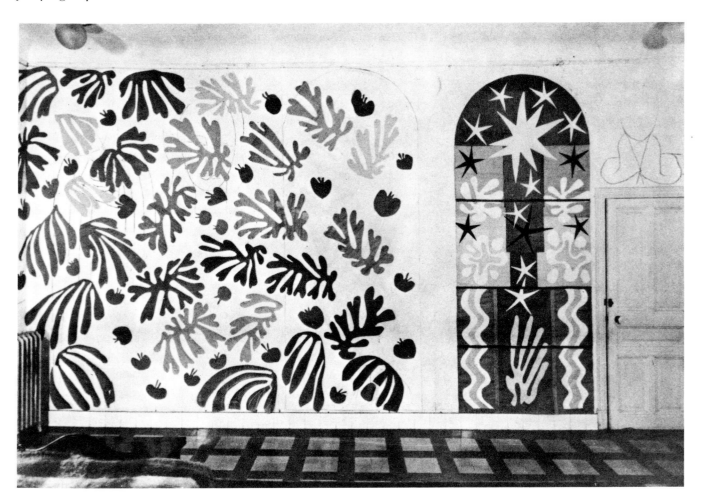

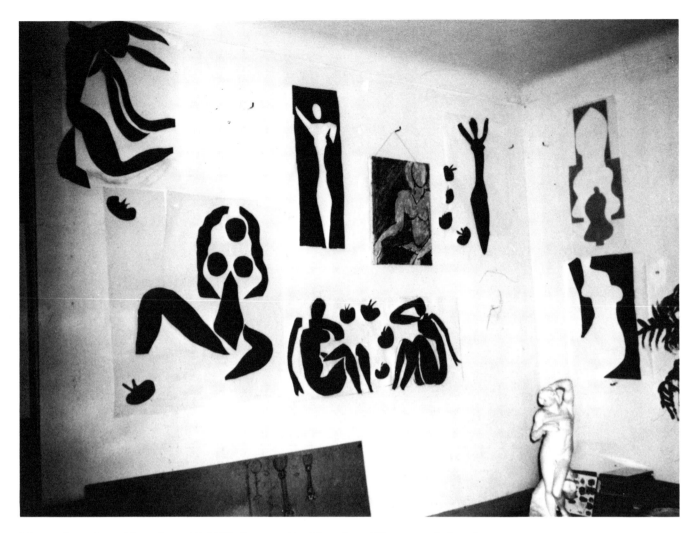

Matisse's studio at Nice, June 17, 1952. Top row: *La Chevelure; Woman with Amphora* (early state); the 1951 painting, *Katia in a Yellow Dress; Woman with Amphora and Pomegranates* (early state); *The Bell.* Bottom row: *The Frog;* the women of *Women and Monkeys* (Pl. 42); *Venus* (Pl 37). Bottom left: chalice designs for the Vence Chapel. In the corner: a plaster reproduction of Michelangelo's *Bound Slave.*

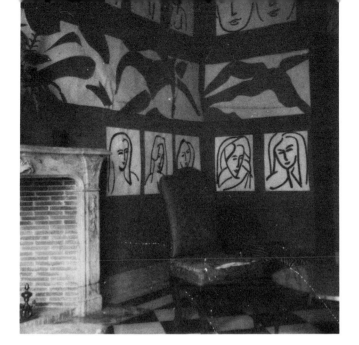

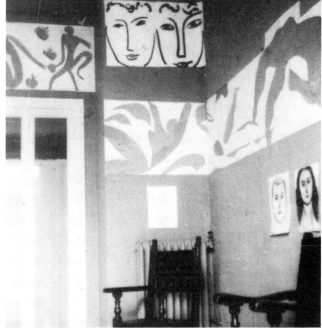

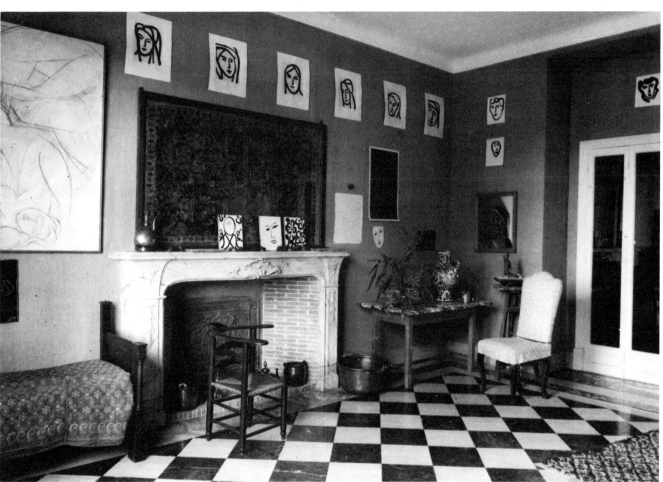

Above: Matisse's dining room at the Hôtel Régina, Nice, before *The Swimming Pool* (Pl. 27) was made. Top: two views of sections of *The Swimming Pool* showing how it was originally surrounded by other works of art. The following two pages show the two sides of the dining room with the elements of *The Swimming Pool* still pinned to the wall. (The pins are particularly noticeable on page 116 top left).

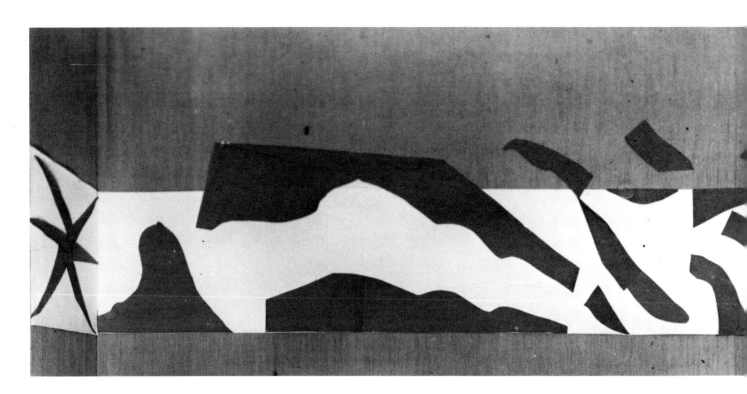

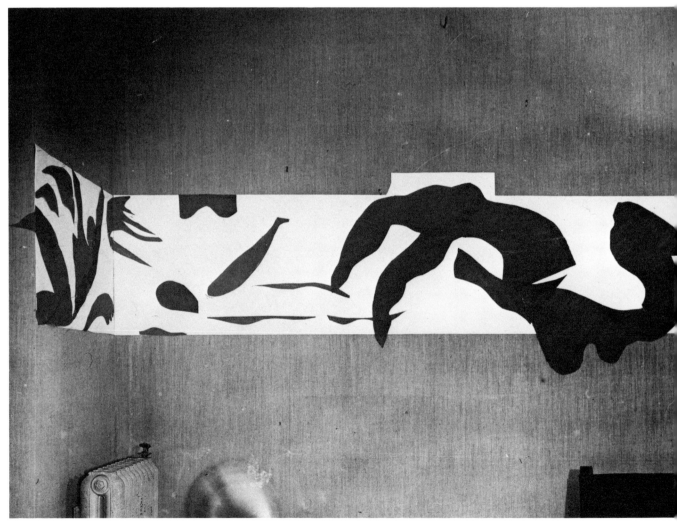

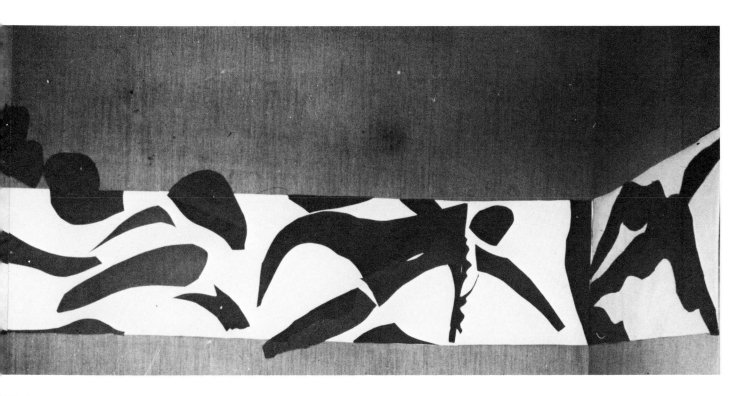

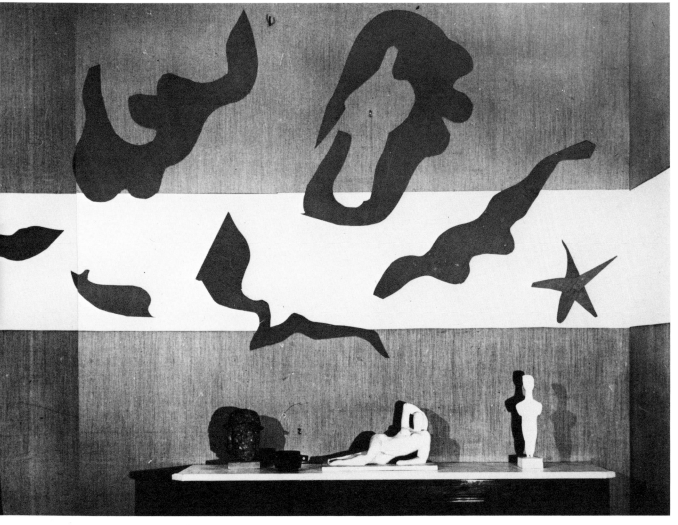

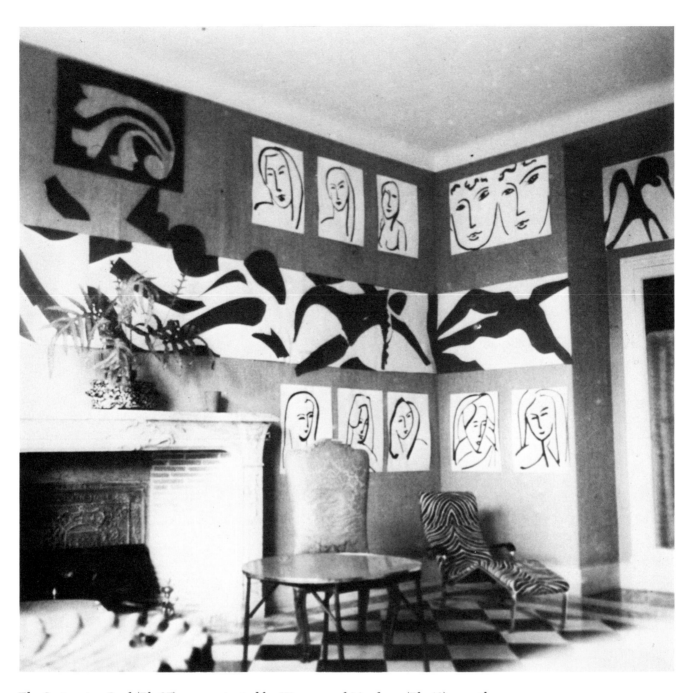

The Swimming Pool (Pl. 27) as punctuated by *Women and Monkeys* (Pl. 42) over the doorway. The 1952 photograph above shows the cut-outs still surrounded by drawings and with the cut-out *The Snail* to the extreme top left. Visible through the doorway in the 1953 photographs opposite are *Acrobats* (Pl. 36) and *Rose Chasuble* (preliminary design) (see p. 106).

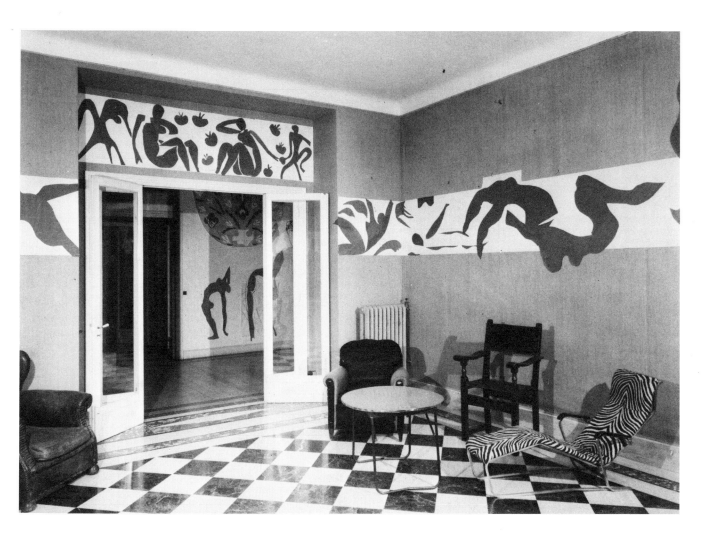

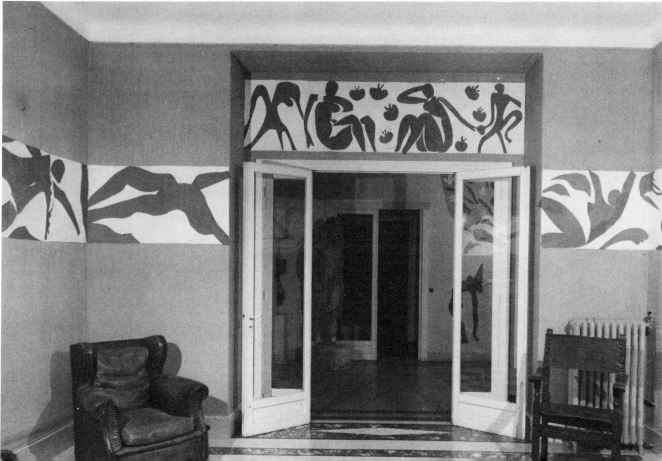

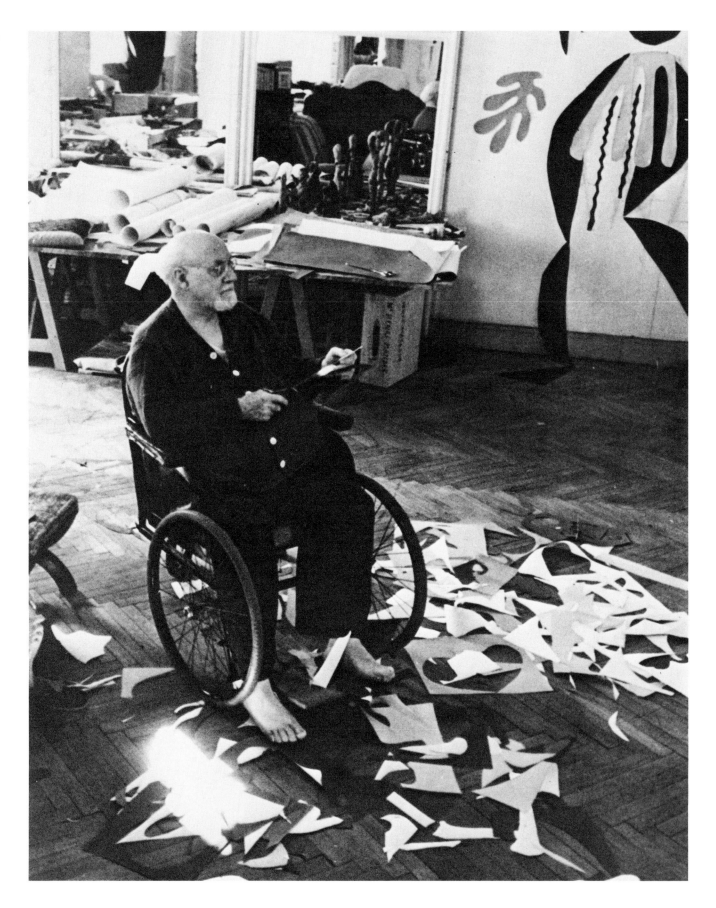

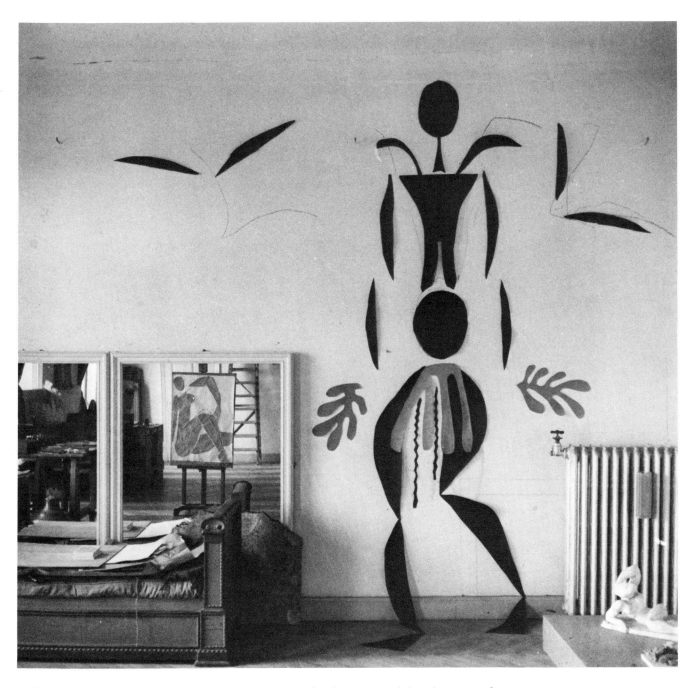

Left: Matisse at work in his Nice studio in 1952 with *The Negress* (Pl. 40) in its early state. Above: *The Negress* in its early state around April 1952. Visible in the mirror, an early state of *Blue Nude IV* (Pl. 35), begun before Blue Nudes I–III and finalized after they were completed. To the lower right, Matisse's 1906–07 sculpture, *Reclining Nude I*.

The Negress as seen below is in the same state as in the April 1952 photograph, page 121. However, *Large Decoration with Masks* (Pl. 41) is in an advanced state, dating the photograph to around February 1953. The photographs of *The Negress* opposite show how its final form was realized by adding four-leaf patterns derived from *Large Decoration with Masks.* In front of the mirror to the left: a group of Matisse's last sculptures of 1950 that have been allowed to dry out and crack apart.

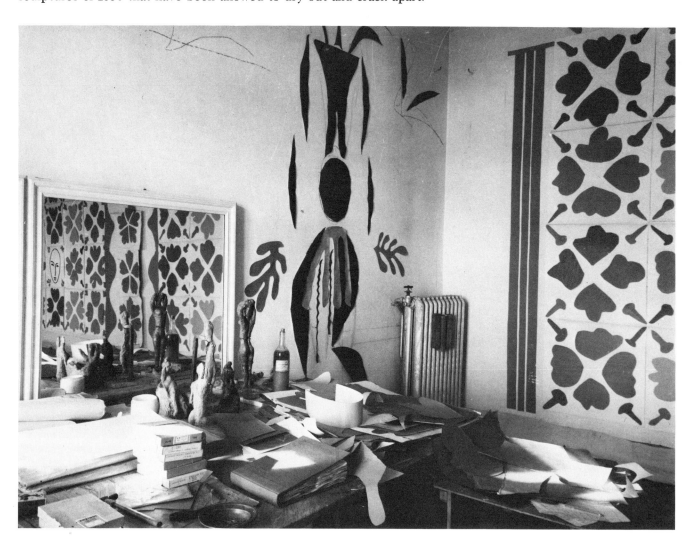

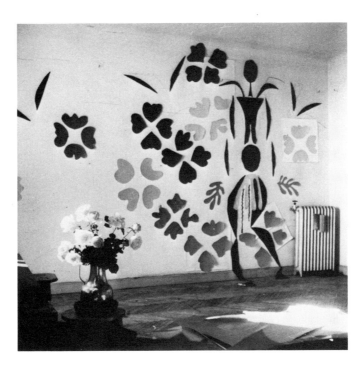

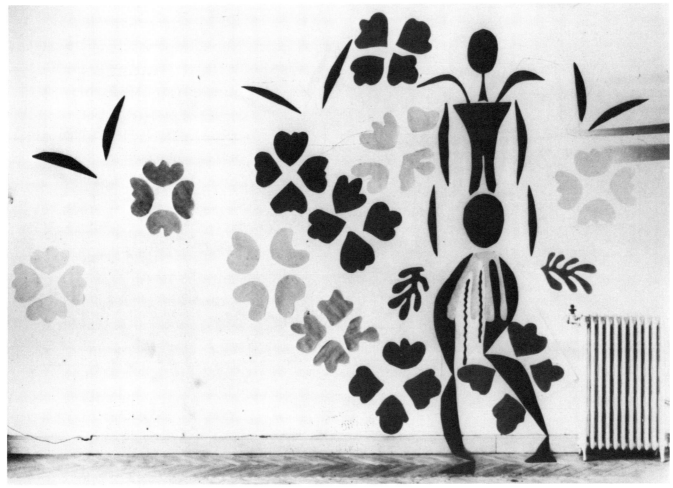

Below: *Large Decoration with Masks* (Pl. 41) in late January–early February 1953, at an earlier state than seen on page 122. This is the same section of Matisse's Nice studio as shown on page 114 in June 1952. A fragment of *La Chevelure* is visible to the extreme left. In the corner: *Woman with Amphora and Pomegranates, The Bell, Venus* (Pl. 37). Below these cut-outs is a plaster reproduction of Michelangelo's *Bound Slave*, and on the wall to the right, Matisse's *Sleeping Nymph and Faun Playing a Flute* (begun 1935). Right: Matisse inspecting the broken clay sculpture of a seated woman, seen also on page 122. To the extreme right: Matisse's *Back IV* of 1931.

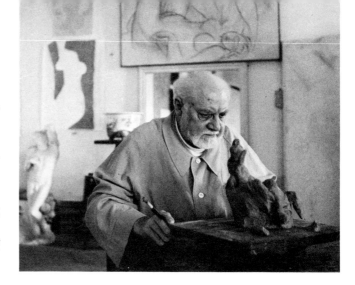

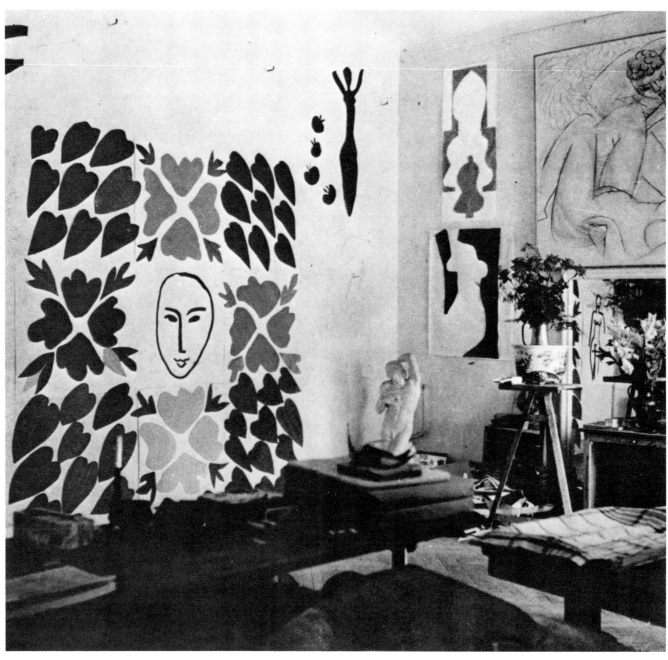

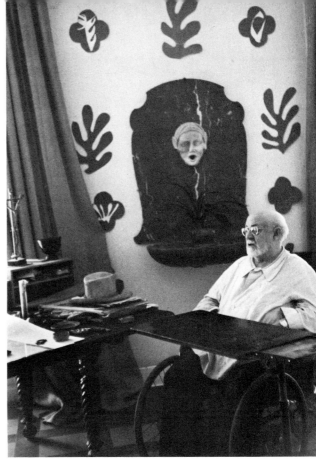

Below: *Large Decoration with Masks* (Pl. 41) in a photograph probably taken at the same time as that on page 122. Right: Matisse seated in front of an antique marble lavabo surrounded by decorative cut-out forms, a combination which may have suggested the format of *Large Decoration with Masks*.

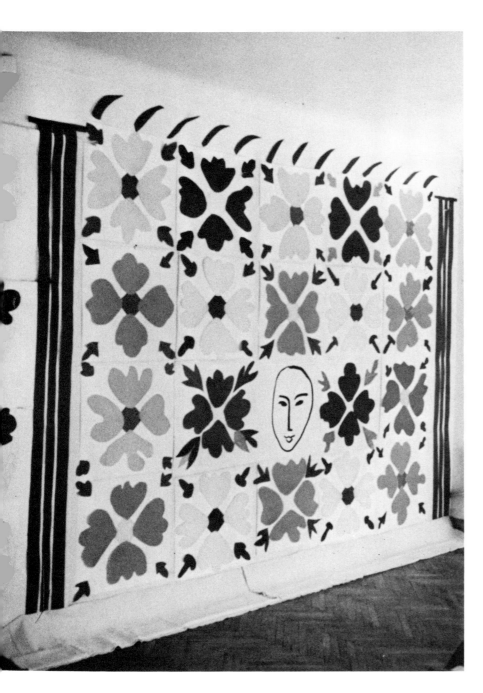

Below: Matisse's Nice studio in 1953 with *Large Decoration with Masks*, drawings of heads and acrobats, the reproduction of Michelangelo's *Bound Slave* below the cut-out *Nude with Oranges*, Matisse's *Back IV* of 1931 and a painted idol from New Caledonia. Right: A view of Matisse's bedroom taken after his death in 1954. On top of the drawings on the wall (visible in earlier photographs of the bedroom) are: left, *The Vine*; top, *The Wild Poppies* (Pl. 43); right, *Rose*.

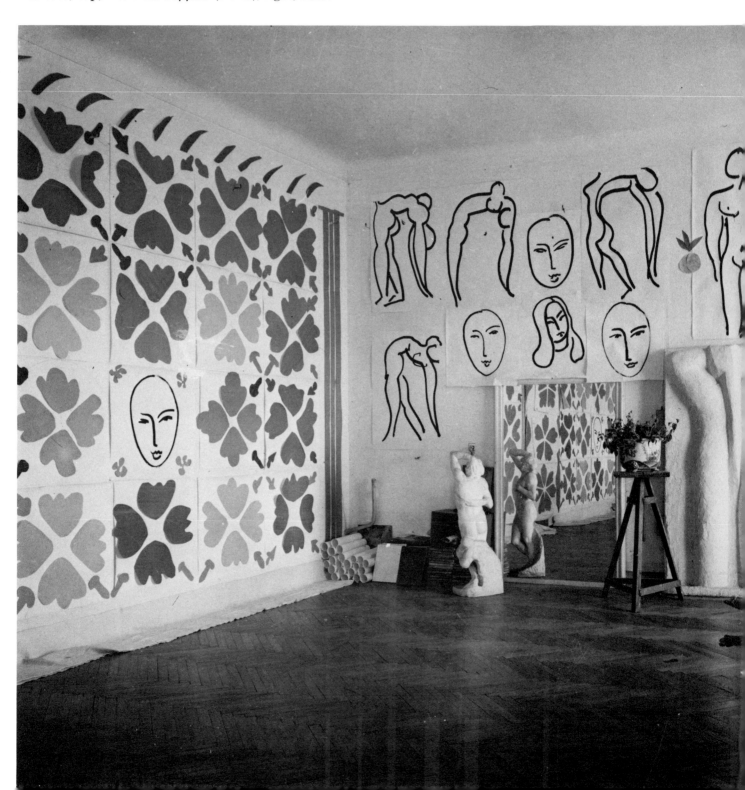

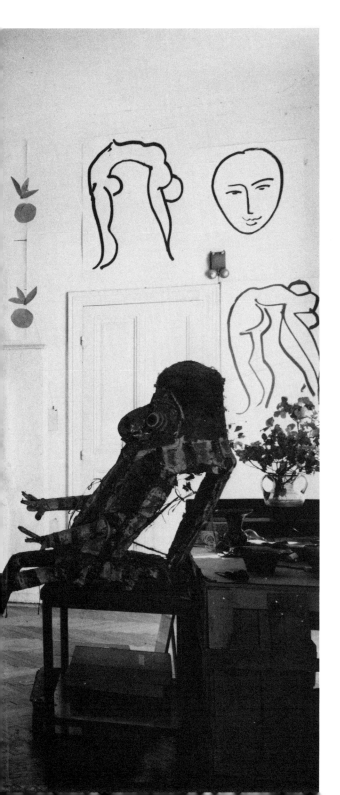

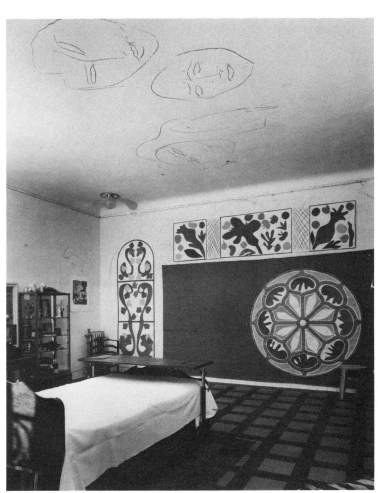

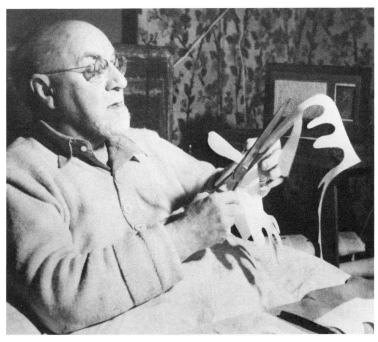